Genre Filmmaking

Genre Filmmaking

A Visual Guide to Shots and Style

DANNY DRAVEN

Focal Press
Taylor & Francis Group

NEW YORK AND LONDON

First published 2013
by Focal Press
70 Blanchard Road, Suite 402, Burlington, MA 01803

Simultaneously published in the UK
by Focal Press
2 Park Square, Milton Park, Abingdon, Oxon OX14 4RN

Focal Press is an imprint of the Taylor & Francis Group, an informa business

Notices
Knowledge and best practice in this field are constantly changing. As new research
and experience broaden our understanding, changes in research methods,
professional practices, or medical treatment may become necessary.

Practitioners and researchers must always rely on their own experience and
knowledge in evaluating and using any information, methods, compounds, or
experiments described herein. In using such information or methods they should
be mindful of their own safety and the safety of others, including
parties for whom they have a professional responsibility.

Product or corporate names may be trademarks or registered trademarks, and
are used only for identification and explanation without intent to infringe.

Library of Congress Cataloging-in-Publication Data
Draven, Danny.
Genre filmmaking / Danny Draven.
p. cm.
1. Cinematography. 2. Motion pictures--Production and direction. I. Title.
TR850.D73 2012
777--dc23
2012034210

ISBN: 9780240824215 (pbk)
ISBN: 9780240824529 (ebk)

Printed and bound by 1010 Printing International Ltd, China

CONTENTS

This book is dedicated to the memory of Gladys, Alvin, and Michael B. Hageman

Dayton, Ohio

Jojo Draven

Lucas and Leia

John and Bailee Assalone

Marlene Brown

Mike Brown

Mami & Papi Takim

Albert "Koko" & Siane Soegijopranoto

Stefan Soegiarto

Loui & Ika Sugiyanto

Jennifer, Devyn and Olivia Takim

Jason Rouch

Sheena & Shawn Rolsen

Charles Band

Full Moon Features

Helene Hill

Stuart Gordon

Dave & Sandra Lange

Darkmatter Studios

David DeCoteau

Rapid Heart Pictures

Nakai Nelson

Bo, Leroy and Colin at Full Moon Features

Ian Irizarry

Aunt Cecil and Uncle Butch

Elinor Actipis

Lauren M. Mattos

Dennis McGonagle

Michael "Fish" Scofield

Focal Press

Taylor & Francis

Dark Delicacies

Producers Guild of America

Peter Linsley

Software Contributors

Paul Clatworthy – PowerProduction Software

Storyboard Artist Studio

www.powerproduction.com

The author professionally uses this software for all shot/storyboard visuals.

FACEBOOK RESEARCH TEAM

Demetria Vance

Eric Spudic

Scott Perkins

Matthew Kindell

Tony D. 'Tygr'

Marlene Brown

Mike Brown

Jerrod Brito

Brian Harris

Dennis McGonagle

Jade Olsen

Jamie Brown

Phil Brown

Patrick Hall

Christopher D. Little

Neal Hallford

John Ward

Jason Rouch

Kenneth Brown

Gina Ortiz-Sodano

A special thanks to all you film geeks out there with great "movie memory."

1

The Horror Genre

Horror | an overwhelming and painful feeling caused by something frightfully shocking, terrifying, or revolting; a shuddering fear.

The Scary Dolly Zoom

What does it look like?

It's an unsettling effect used to distort the visual perception of the image. The subject is meant to stay the same size in the frame as a continuous perspective distortion happens around it. The most recognizable shift is the background changes size and focus relative to the subject.

How's it done?

It's achieved in-camera by pulling away from a still subject while the lens zooms in, or vice-versa. You can use a dolly, Steadicam, or it can be handheld.

When should I use it?

It's a great visual tool to use in those moments of realization when everything changes in the world of the character.

JAWS (1975)

Synopsis: A giant killer shark terrorizes a small town.

Featured Scene: On a crowded beach the sheriff (Roy Schneider) witnesses a brutal shark attack on a young boy.

Jaws (1975), Directed by Steven Spielberg

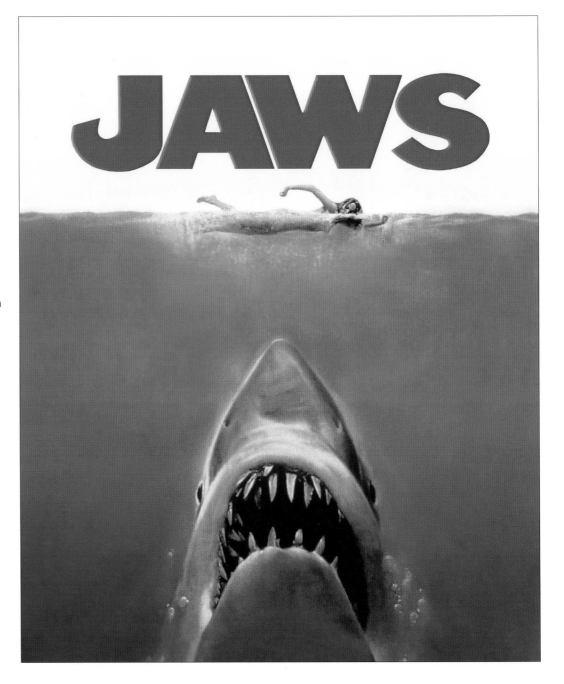

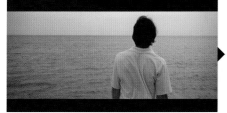

1

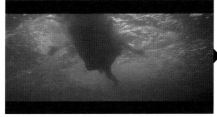

2

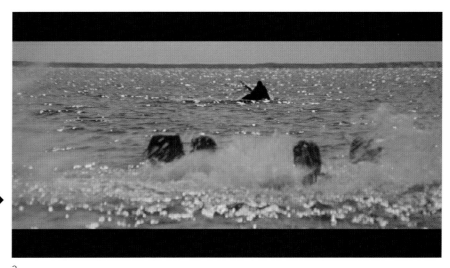

3

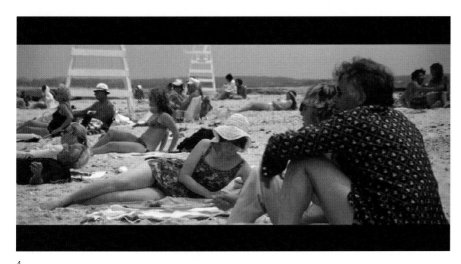

4

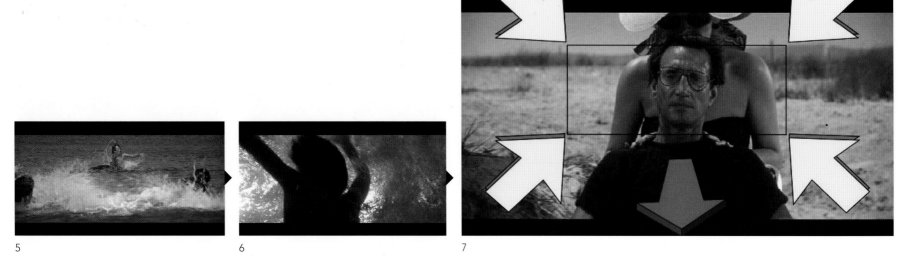

5 6 7

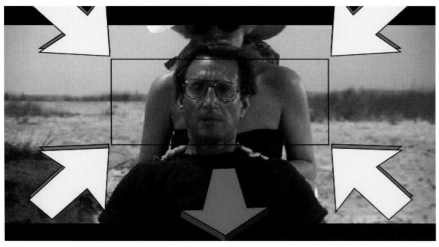

8

WHITE ARROWS (Lens zooms in). RED ARROW (Camera pulls back on dolly)

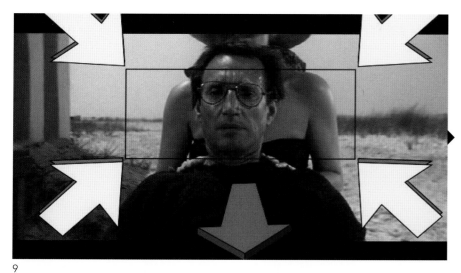

9

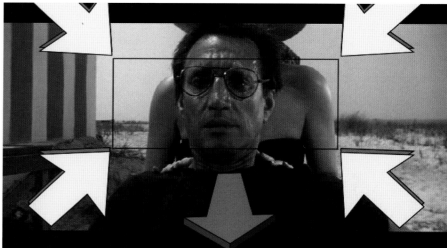

10

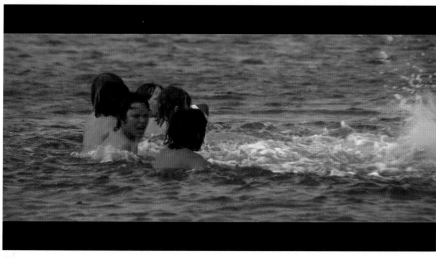

11

12

DEAD ALIVE (1992)

Synopsis: A young man's mother is bitten by a Sumatran rat-monkey and turns into a hideous zombie who soon infects others.

Featured Scene: In the basement Lionel's (Timothy Balme) problems multiply when three new zombies are unleashed.

Dead Alive (1992), Directed by Peter Jackson

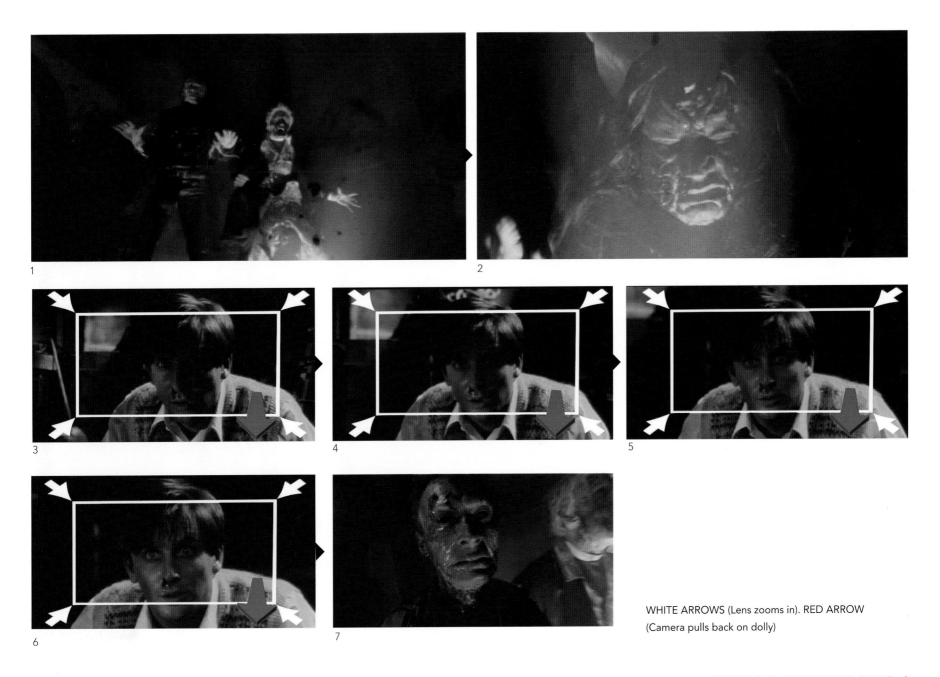

WHITE ARROWS (Lens zooms in). RED ARROW
(Camera pulls back on dolly)

THE HOLE (2009)

Synopsis: Two brothers uncover a hole in their basement that leads to the darkest corridors of their fears and nightmares.

Featured Scene: A young boy is chased by a killer doll and escapes from the basement to the kitchen, but he's not yet safe from the threat.

The Hole (2009), directed by Joe Dante

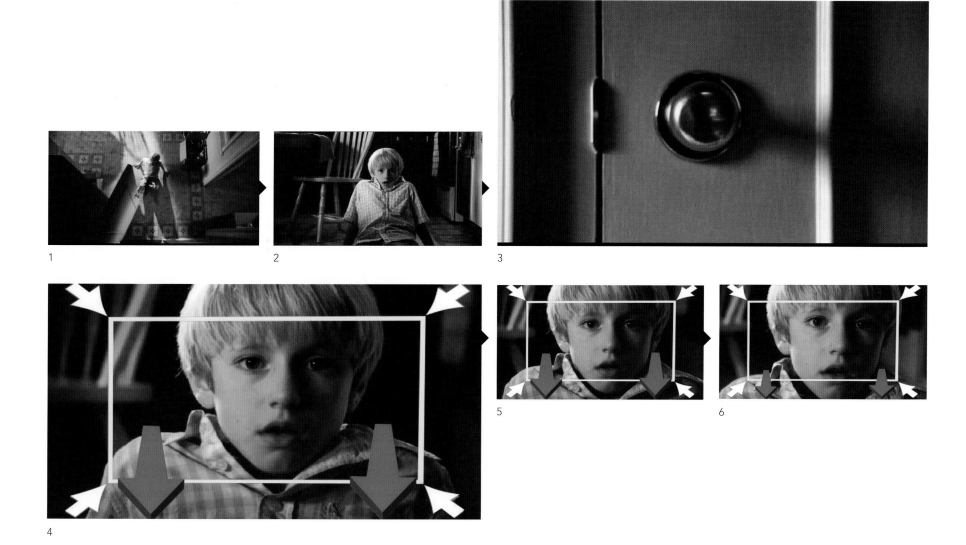

WHITE ARROWS (Lens zooms in). RED ARROW (Camera pulls back on dolly)

The Ghost Reveal

What does it look like?

It's a moment of revelation when the ghost appears to the audience's eye, but not to the character.

How's it done?

It can be done as a practical shot on set, or more commonly, as a CGI effect in post-production.

When should I use it?

When the audience sees the ghost but the character (or at least one of the characters) doesn't.

THE MESSENGERS (2007)

Synopsis: On a farm in North Dakota, the Solomon family is torn apart by suspicion, mayhem and murder.

Featured Scene: In the bedroom a mother is making the bed with her toddler watching. When she shakes the sheets, the audience and the toddler see the ghost manifest underneath.

The Messengers (2007), directed by the Pang Brothers

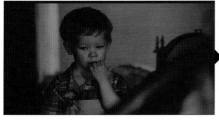

1

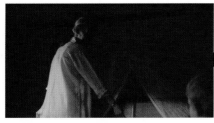

2

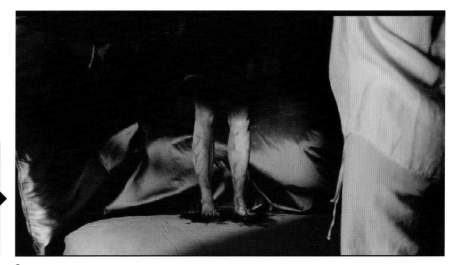

3

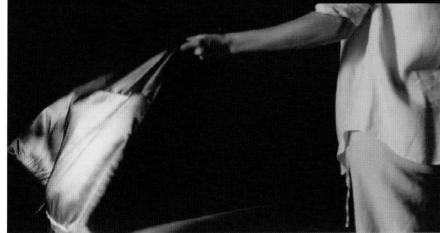

4

This sequence was enhanced using CGI for the ghost reveal.

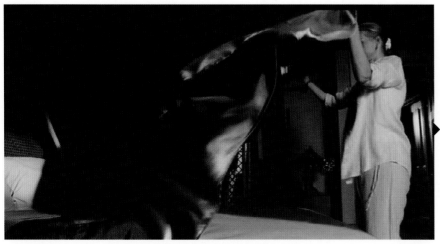

5

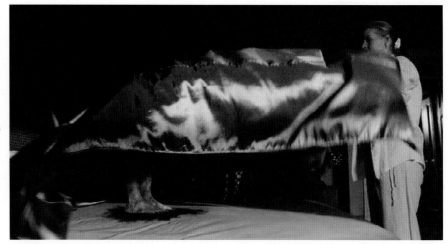

6

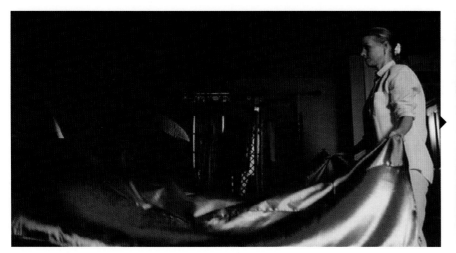

7

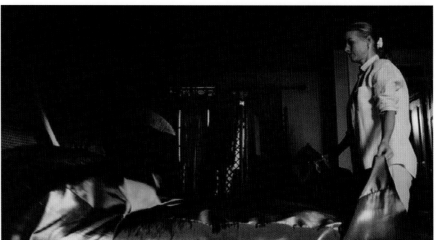

8

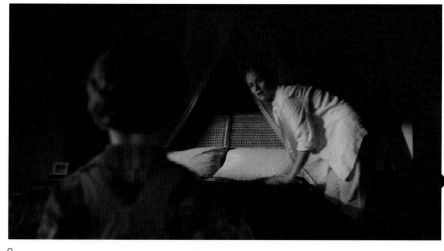

9

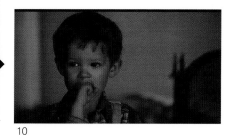

10

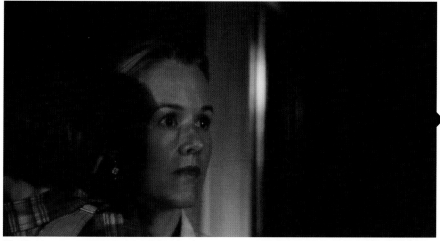

11

12

THE CHILD'S EYE (2010)

Synopsis: A group of friends find themselves stranded in an old hotel and uncover something sinister lurking behind the walls.

Featured Scene: A group of friends gets caught outdoors during a violent riot and during the mayhem a dead woman is revealed through the crowd.

The Child's Eye (2010), directed by the Pang Brothers

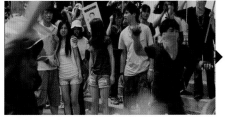

1

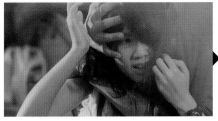

2

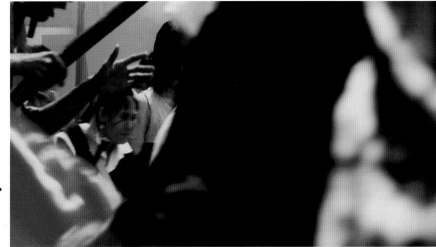

3

4

This sequence was shot practically on set. The editing is hidden when the frame goes black as people pass by in front of the lens. This reveal works well and is seen in a variety of horror movies.

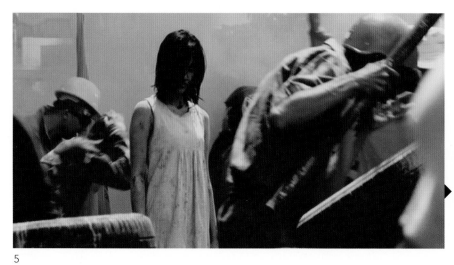

5

6

7

8

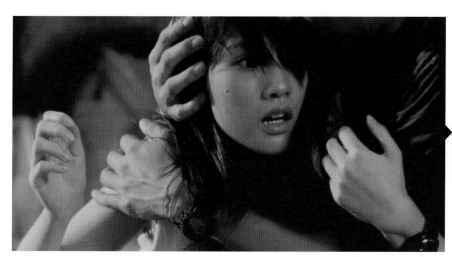

9

10

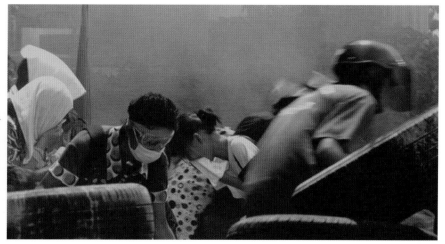

11

12

THE EYE (2008)

Synopsis: A blind woman receives an eye transplant that allows her to see into the supernatural realm.

Featured Scene: In a coffee shop during the afternoon, Sydney (Jessica Alba) is visited by a dead woman with a message.

The Eye (2008), directed by David Moreau and Xavier Palud

Cellular Memory \ˈsel-yə-lər\ \ˈmem-rē\:
a phenomenon in which transplant recipients
display characteristics of the donor

JESSICA ALBA

THE EYE

YOU WON'T BELIEVE HER EYES

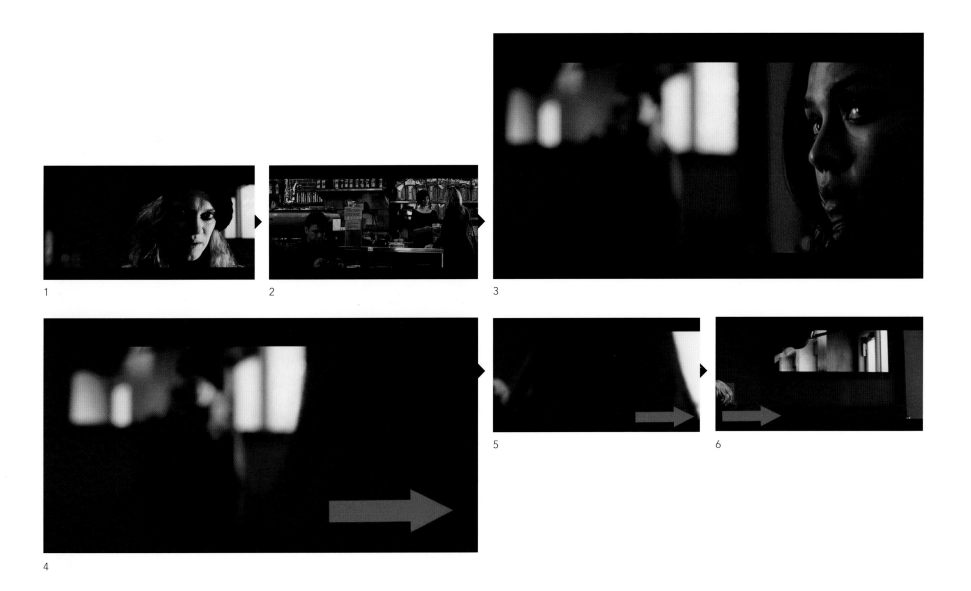

1

2

3

4

5

6

The camera quickly dollies (left to right) past the back of her head to reveal the ghost has vanished.

The Weapon POV

What does it look like?
It should resemble what it would be like if the audience member was holding the weapon from the character's POV. It could be just the tip of the weapon or as much as the entire weapon and a bit of the arm or hand holding it.

How's it done?
You can add the weapon in post-production or get creative and rig it to the front of the camera when shooting your sequences.

When should I use it?
It's a shot to emphasize the weapon being used and its effectiveness against a creature or threat.

EVIL DEAD 2 (1987)

Synopsis: After surviving an onslaught of flesh-possessing demons, a lone survivor gets trapped inside a cabin with a group of strangers as all hell breaks loose—literally.

Featured Scene: When Ash (Bruce Campbell) saws off his own hand, it takes on a life of its own and attacks him. He goes after the menacing body part with his shotgun.

Evil Dead 2 (1987), directed by Sam Raimi

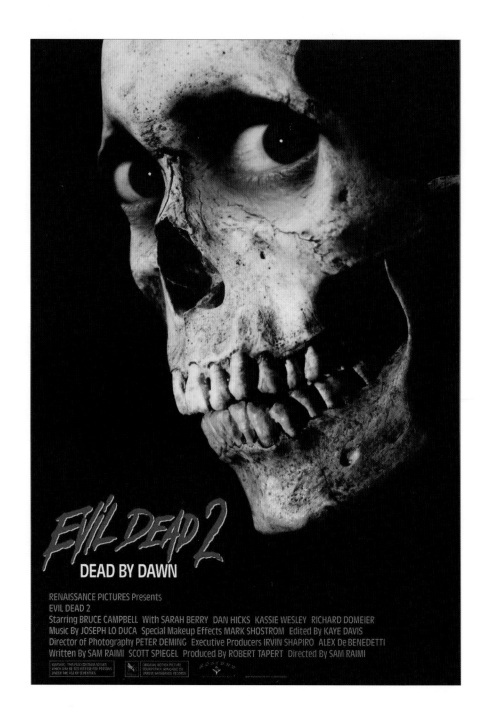

1

2

3

4

5

6

7

8

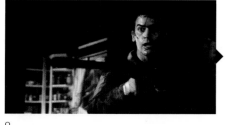

9

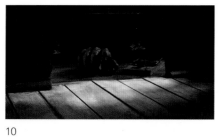

10

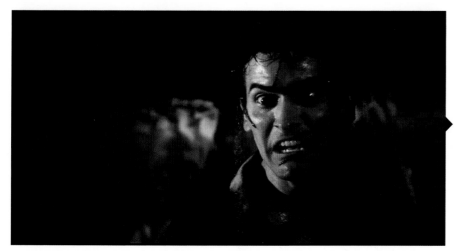

11

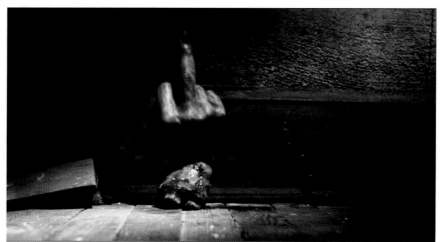

12

DOOM (2005)

Synopsis: Space marines are sent to Mars to investigate a research facility that they find has been taken over by genetically enhanced killing machines.

Featured Scene: During a search for his sister Samantha, John Grimm (Karl Urban) makes his way through dangerous corridors in the "weapon POV" mode battling a variety of creatures.

Doom (2005), directed by Andrzej Bartkowiak

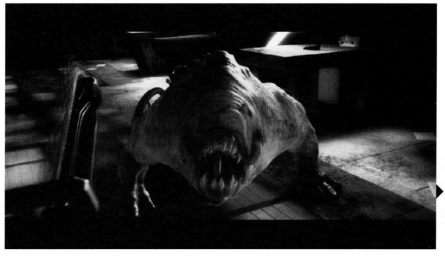

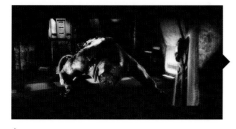

1

2

3

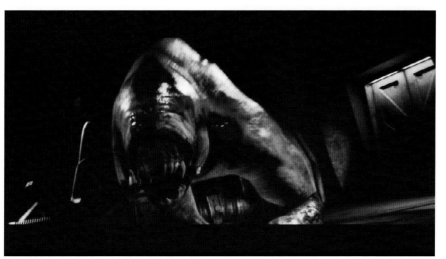

4

5

6

7

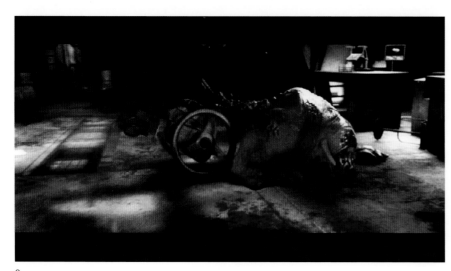

8

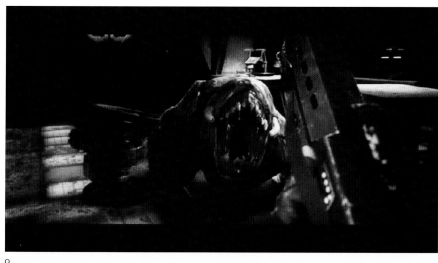

9

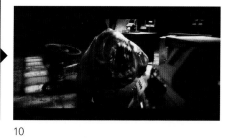

10

11

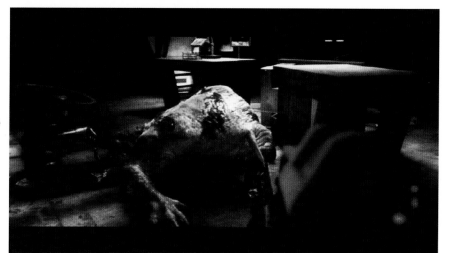

ARMY OF DARKNESS (1992)

Synopsis: When Ash (Bruce Campbell) is accidentally transported back in time, he must battle an army of the undead and retrieve the Necronomicon so he can return home.

Featured Scene: After Ash escapes the pit of evil, he is faced by an amazed crowd that cowers at the sight of his "boom stick".

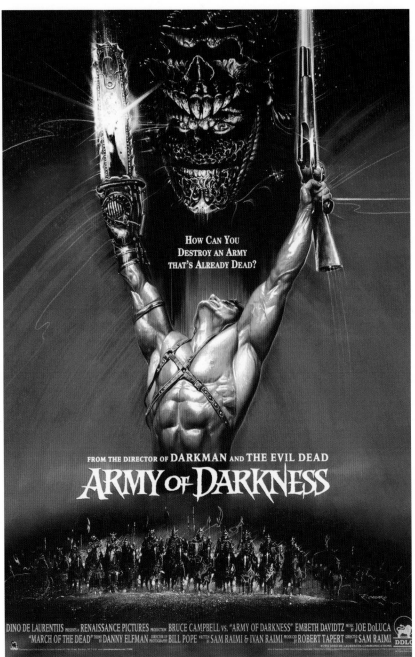

Army of Darkness (1992), directed by Sam Raimi

1

2

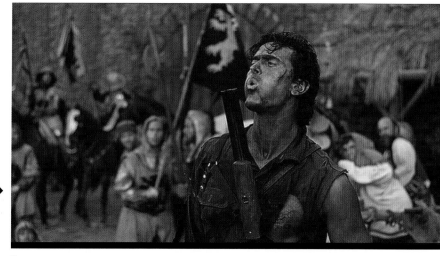

3

4

5

6

The Victim's Eye

What does it look like?

This shot is a close up of the eye in which we see a reflection of some event or person.

How's it done?

The reflection portion of this shot is done in post-production.

When should I use it?

This shot works great as a way to get a glimpse of the killer, a weapon, or an important piece of story information, or to show the audience what the victim saw before dying.

SCREAM (1996)

Synopsis: A killer known as Ghostface begins killing off teenagers, and as the body count begins rising, one girl and her friends find themselves contemplating the rules of horror films as they find themselves living in a real-life one.

Featured Scene: In the principal's office, Ghostface attacks the principal (Henry Winkler) and stabs him to death.

Scream (1996), directed by Wes Craven

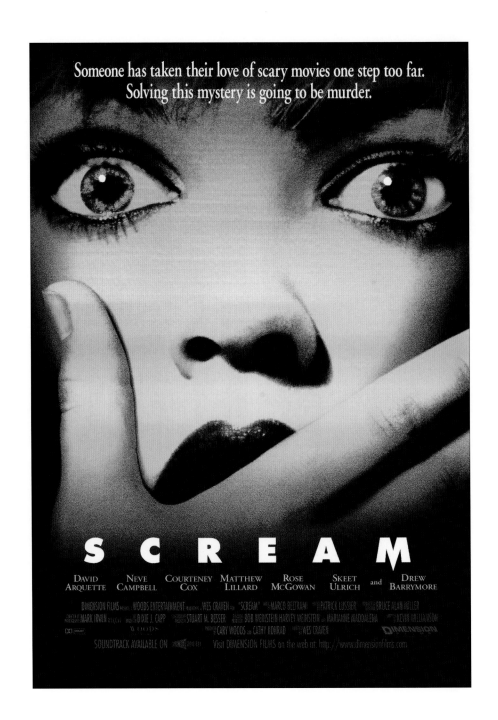

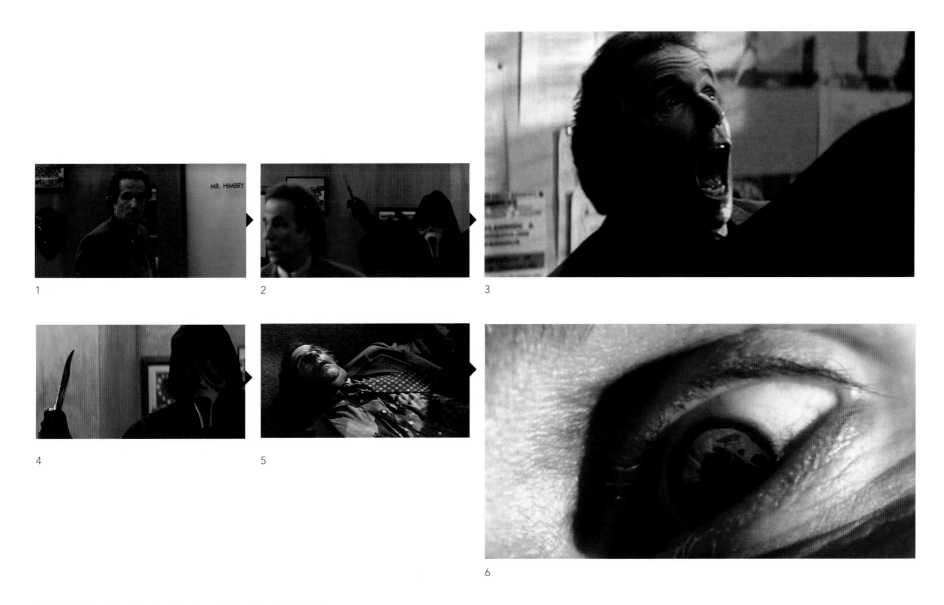

1

2

3

4

5

6

Notice the last shot with the reflection of Ghostface in Winkler's eye

The Body Split

What does it look like?

It's any shot where an object or weapon penetrates a person at a rapid speed and after a moment their body splits in a way that matches the impact.

How's it done?

This type of shot can be done in many ways, but it's usually a combination of on set makeup FX and CGI.

When should I use it?

This type of shot is great for "shock" value and to really make the audience squirm or sometimes even laugh.

FINAL DESTINATION 2 (2003)

Synopsis: When a young woman has a violent premonition of a high-way catastrophe, she blocks the others from meeting their fate on that day, but soon the survivors start dying off in horrific ways.

Featured Scene: When a TV news van explodes it sends a barbed wire fence hurling though the air and tearing through one of the doomed survivors.

Final Destination 2 (2003), directed by David R. Ellis

1

2

3

4

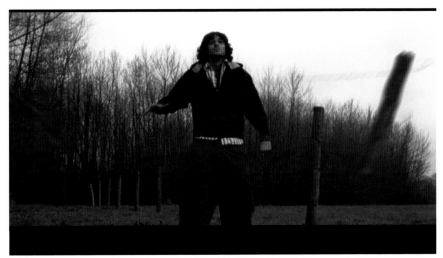

5

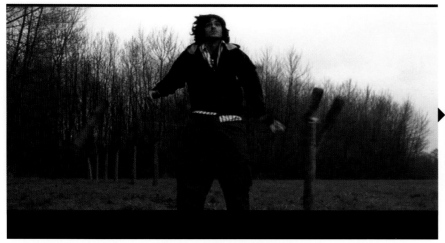

6

7

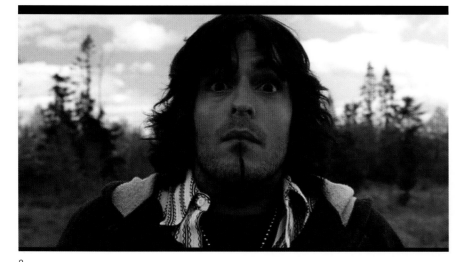

8

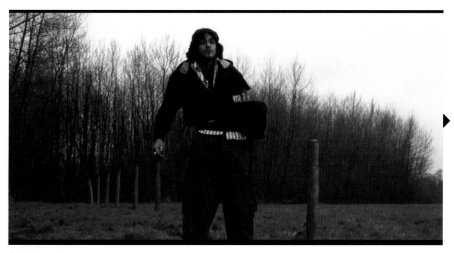

9

10

11

12

SLITHER (2006)

Synopsis: When a small town is taken over by an alien plague, it turns the residents into zombies and bizarre mutants.

Featured Scene: In a field during an attempt to capture the mutant, it attacks with its razor-sharp tentacle and slices a man in half.

Slither (2006), directed by James Gunn

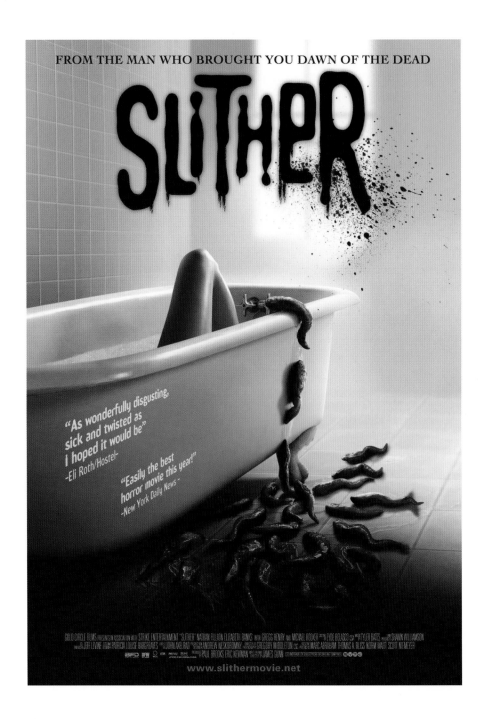

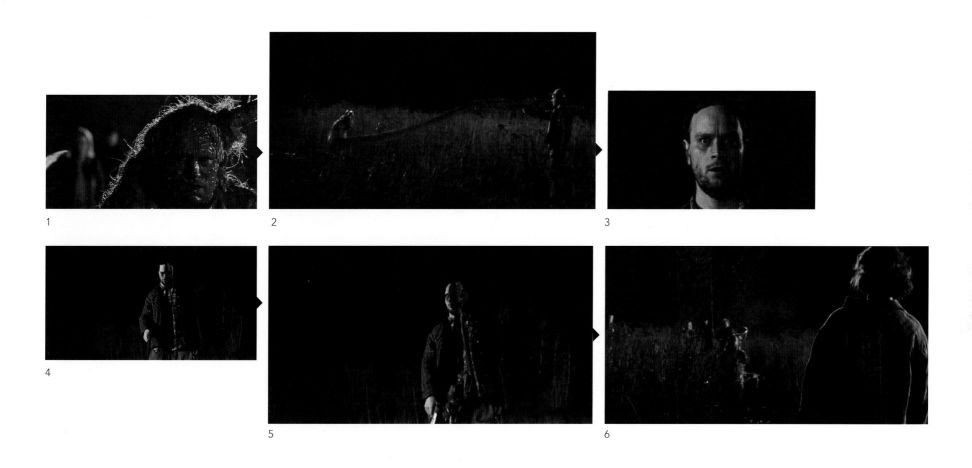

1

2

3

4

5

6

Silhouette Reveal

What does it look like?

It's a shot that starts with a silhouette of the character and then a light source illuminates him briefly for a quick reveal to the audience.

How's it done?

This shot is usually done on set and is mostly seen during a lightning storm.

When should I use it?

This shot is ideal for moments when you only want the audience to get a quick glimpse of the killer or monster and still maintain a sense of terror.

HALLOWEEN 4:
THE RETURN OF MICHAEL MYERS (1988)

Synopsis: Michael Myers returns to Haddonfield to kill his seven-year-old niece on Halloween.

Featured Scene: In the opening of the film, Michael Myers attacks his niece in her bedroom.

Halloween 4 (1988), directed by Dwight H. Little

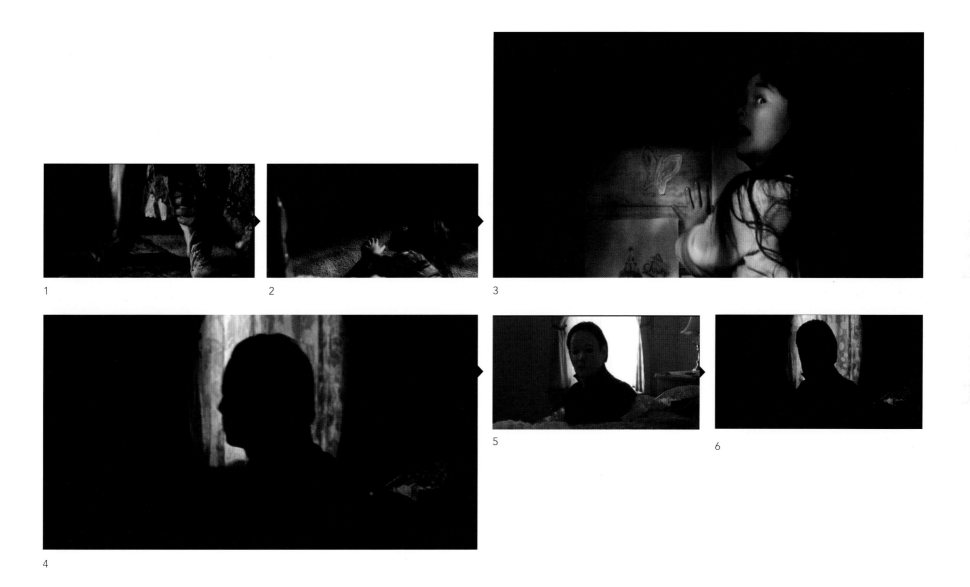

1

2

3

4

5

6

Sequence: /HALLOWEEN 4

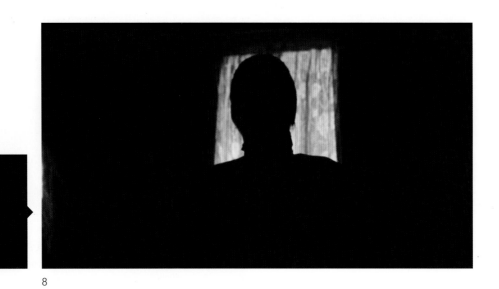

7

8

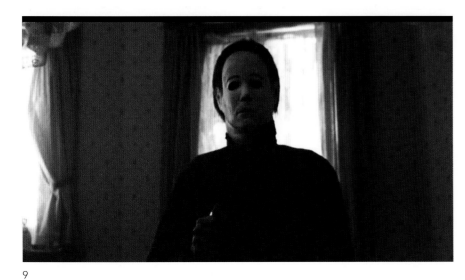

9

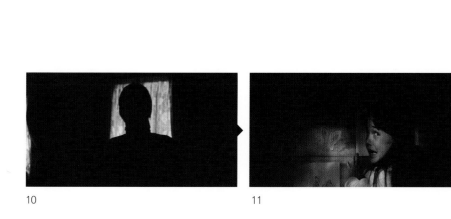

10

11

12

The Gross Out

What does it look like?

It's any shot that uses the gross-out factor within the context of a shot or sequence. It's usually bodily fluids, insects, or a disgusting act of some kind that is shot in a way to completely gross out the audience.

How's it done?

This type of shot is usually done as practical makeup FX on the set, but it can also be enhanced as CGI.

When should I use it?

Use this shot during moments when you want to make your audience or characters squirm. As a rule of thumb, the more extreme the better the result.

DRAG ME TO HELL (2009)

Synopsis: A loan officer who evicts an old woman from her home finds herself the recipient of a supernatural curse. Desperate, she turns to a seer to try and save her soul, while evil forces work to push her to a breaking point.

Featured Scene: While sleeping, Christine is woken up by a fly that crawls in her mouth. She soon realizes she is not alone.

Drag Me To Hell (2009), directed by Sam Raimi

Christine Brown has a good job,
a great boyfriend, and a bright future.
But in three days,
she's going to hell.

DRAG ME TO HELL

COMING SOON
WWW.DRAGMETOHELL.NET

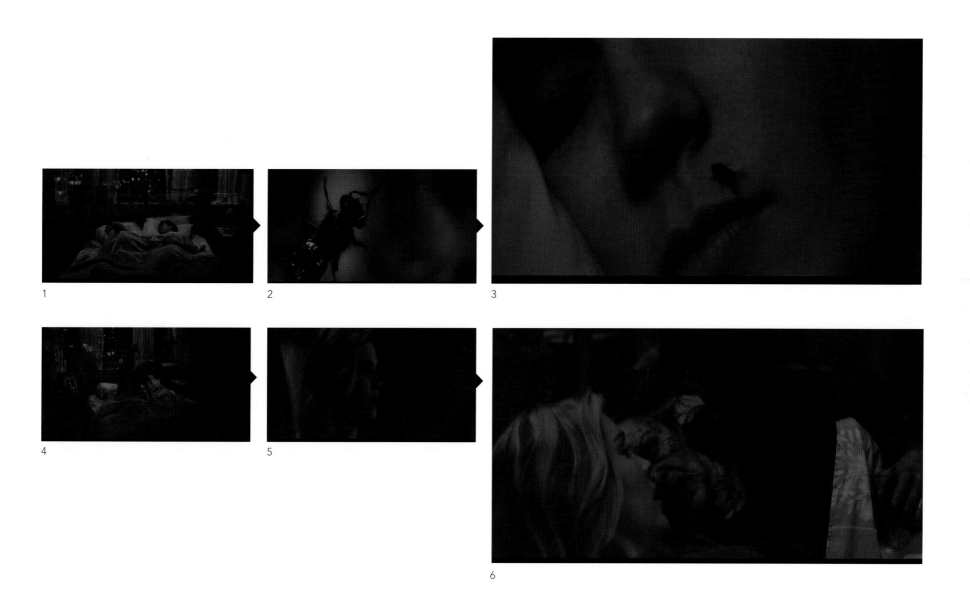

1

2

3

4

5

6

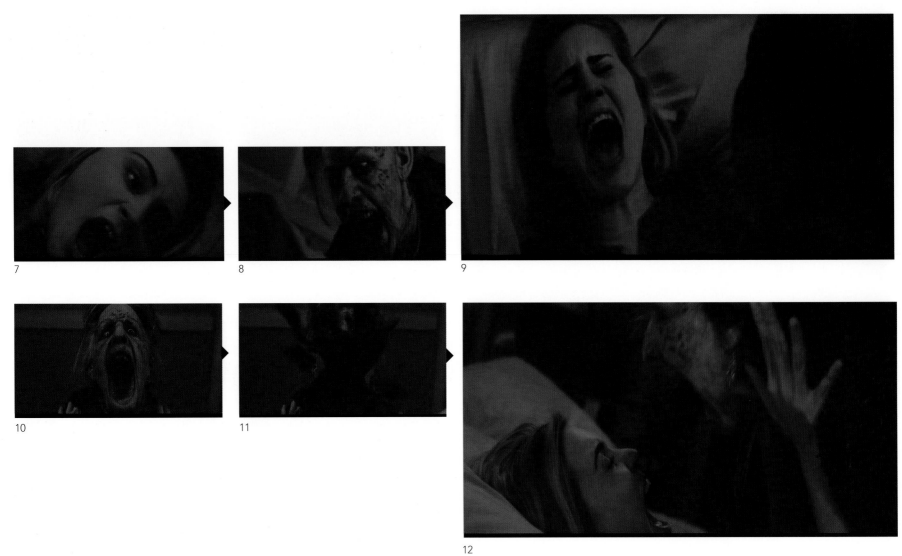

7

8

9

10

11

12

13

14

15

16

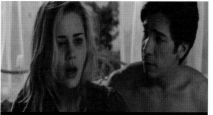

17

THE EXORCIST (1973)

Synopsis: When a girl is possessed by a mysterious entity, her mother seeks the help of two priests to save her daughter.

Featured Scene: When a possessed Reagan (Linda Blair) is tied to the bed, she is confronted by a priest whom she spews vomit at.

The Exorcist (1973), directed by William Friedkin

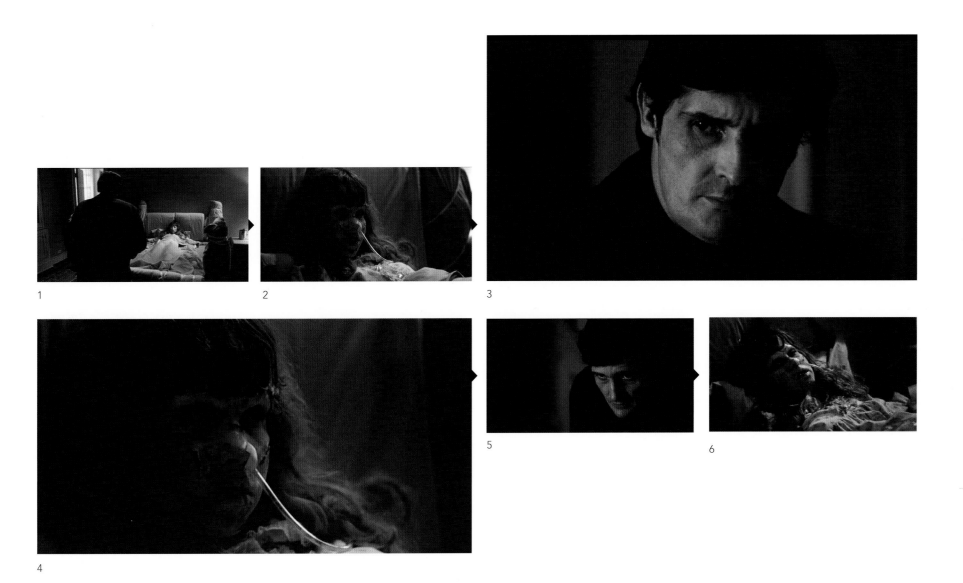

1

2

3

4

5

6

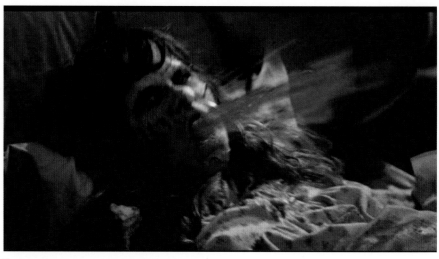

7

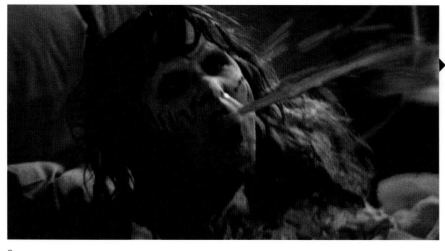

8

9

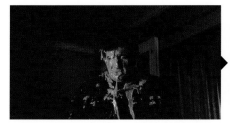

10

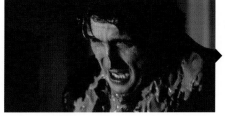

11

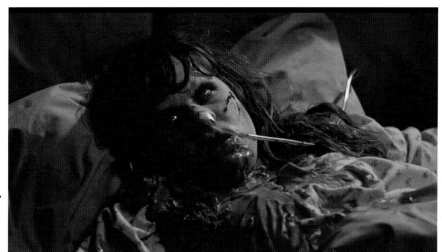

12

The Jump Scare

What does it look like?

It's a quick moment of action within a shot that surprises the audience and character. It could be a creature attacking from an unexpected place or a madman breaking through a window to grab a victim.

How's it done?

It's done by taking the audience off-guard and surprising them with a sudden jolt of action. It works best when the action moment comes from a place the audience and character least expects it.

When should I use it?

It usually works best when the soundtrack starts to quiet down and the audience is made to feel that nothing is about to happen but it soon does and makes them jump from their seats.

FRIDAY THE 13TH (REMAKE) (2009)

Synopsis: A group of young adults discover a boarded up Camp Crystal Lake, where they soon encounter Jason Voorhees and his deadly intentions.

Featured Scene: When Clay (Jared Padaleki) is attacked by Jason from a window behind him.

Friday the 13th (Remake) (2009), directed by Marcus Nispel

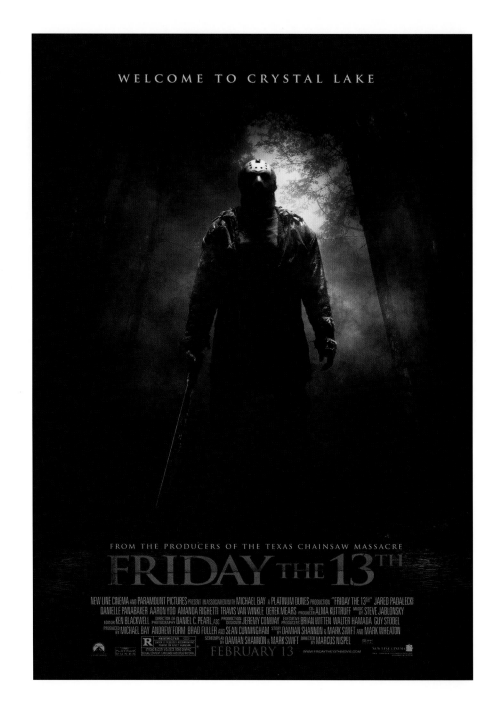

1

2

3

4

5

6

7

8

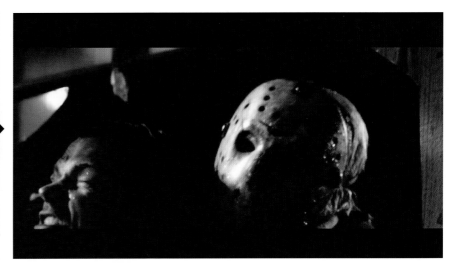

9

10

SECTION ONE THE HORROR GENRE 55

THE EYE 2 (2004)

Synopsis: After a failed suicide attempt, a pregnant woman gains the ability to see ghosts.

Featured Scene: At the bus stop, two bodies drop from above and splatter on the pavement.

The Eye 2 (2004), directed by the Pang Brothers

1

2

3

4

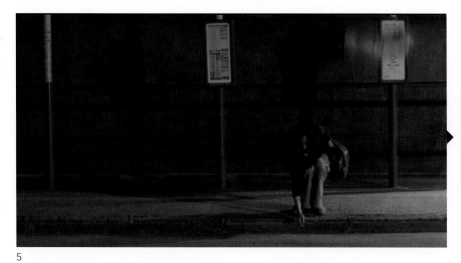

5

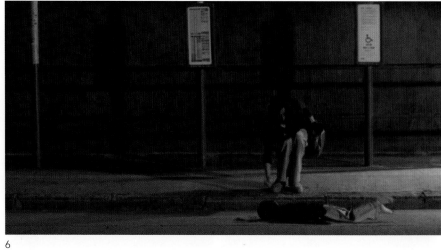

6

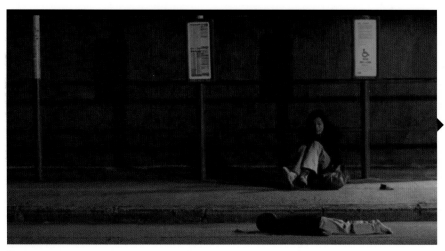

7

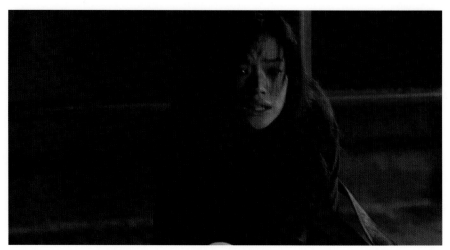

8

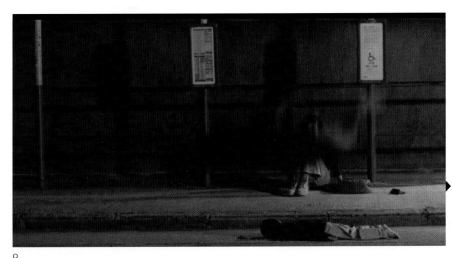

9

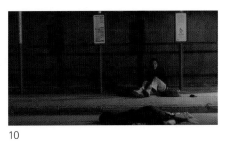

10

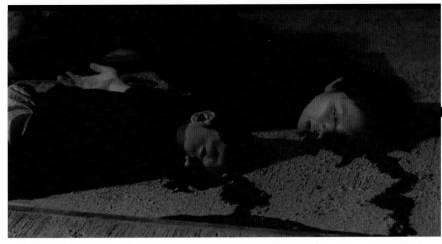

11

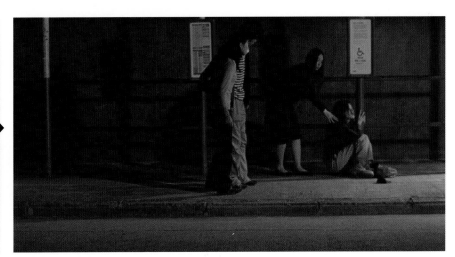

12

Reflection Scares

What does it look like?

It's a shot that reveals a monster or killer in a reflective surface for the audience (not the character) to see. It also reveals the geography of the threat within the context of the shot. It could be behind, above, below or inside of something in the scene.

How's it done?

It's done by carefully blocking the action so the reflection appears in the shot or sequence during the right "scare" moment. It can also be enhanced with CGI, but it's usually done on set with creative lighting and direction.

When should I use it?

It's best to use this shot in moments when you want the audience to get a glimpse of the threat the character is under, but you don't want the character to see the threat. This builds tension and creates suspense for the audience.

CAPTIVITY (2007)

Synopsis: A man and a woman awaken to find themselves captured in a cellar. As their kidnapper drives them psychologically mad, the truth about their horrific abduction is revealed.

Featured Scene: When Jennifer (Elisha Cuthbert) closes a cabinet door the killer is revealed in the reflection.

Captivity (2007), directed by Roland Joffe

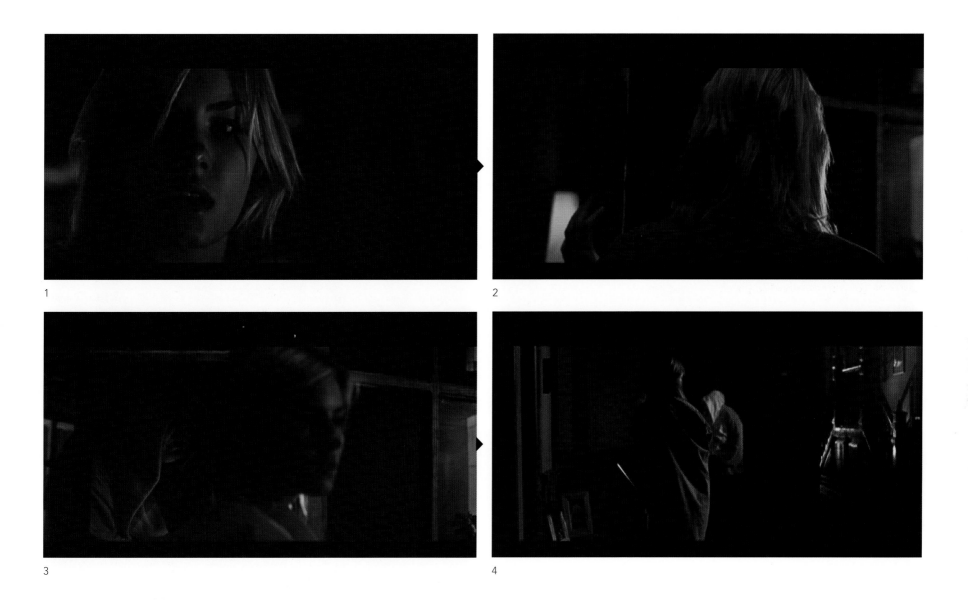

1

2

3

4

THE BROKEN (2008)

Synopsis: From the very first moment Gina (Lena Headey) spots a woman who looks exactly like her driving down a busy London street, reality ceases to exist as she knows it.

Featured Scene: In the bathroom scene, Gina tends to her wound. When she drops something, she bends down to pick it up but her reflection takes on its own life and attacks her.

The Broken (2008), directed by Sean Ellis

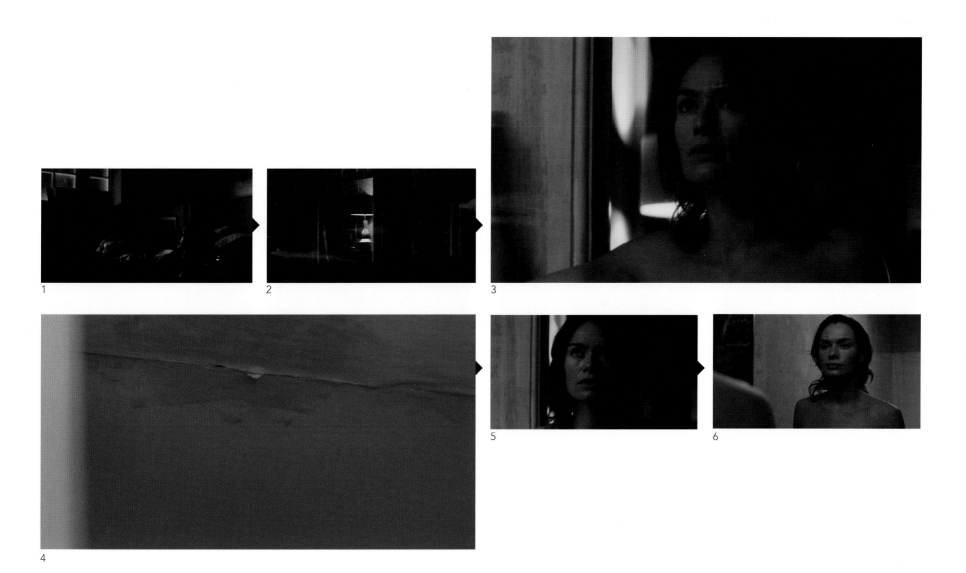

1

2

3

4

5

6

7 8 9

10

11 12

13

14

15

16

17

18

Terror From Behind (Split Focus)

What does it look like?

It's a shot that is in focus in the foreground and also in the background of a frame. You can usually see an out of focus area between the two sharp objects.

How's it done?

The split-focus effect is done in camera using a split-focus diopter. A split diopter is a device that attaches to the lens to make half of it nearsighted. This allows you to focus the lens on one object and the diopter on another creating the illusion of deep focus.

When should I use it?

This shot is best used in moments where you want the audience to focus their attention on two areas of the frame at the same time.

HOUSE OF 1000 CORPSES (2003)

Synopsis: Two teenage couples traveling across the backwoods of Texas searching for urban legends of murder end up as prisoners of a bizarre and sadistic backwater family of serial killers.

Featured Scene: In the underground caverns, a young girl is approached from behind by a monster with an axe.

House of 1000 Corpses (2003), directed by Rob Zombie

1

2

3

4

5

6

7

8

9

The Monster Trap

What does it look like?

This shot reveals the monster in a way that shows the character is trapped by it. The monster usually jumps into the frame or is revealed in a camera move. The character should still be seen in this shot.

How's it done?

It's done by using a wide shot of the character running towards camera and then having the monster come into the foreground blocking the path to escape.

When should I use it?

It's best used in high intensity moments when the character is on the run and is suddenly stopped in his tracks by the creature. It works best when the creature completely cuts off his path to escape and he is forced to face it head on.

TALES FROM THE DARKSIDE: THE MOVIE (1990)

Synopsis: In anthology style, a child tells three stories of horror to keep from being eaten by a witch.

Featured Scene: In the segment "Lover's Vow", Preston (James Remar) tries to escape from a large gargoyle creature that just murdered his friend.

Tales From The Darkside: The Movie (1990), directed by John Harrison

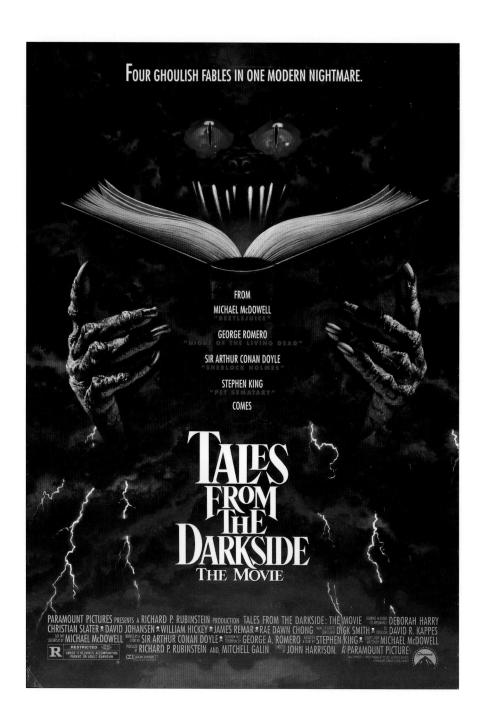

1

2

3

4

5

6

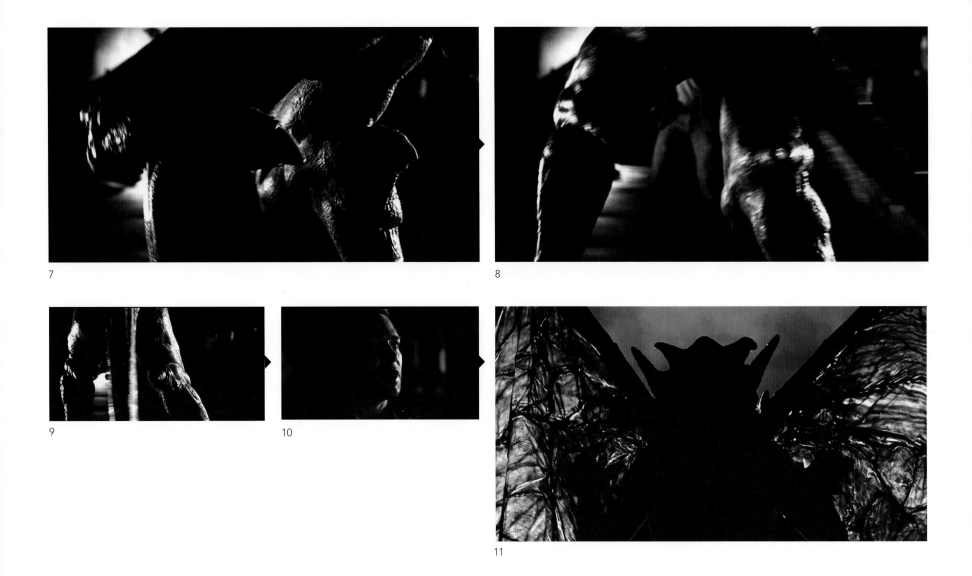

7

8

9

10

11

12

13

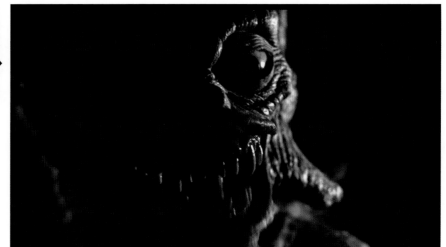

14

The Weapon Shadow

What does it look like?

It's any shot that casts a shadow of a weapon (e.g., knife, gun, axe, etc.) on a surface with the intent of drawing attention to that weapon. It also can distort the size of the weapon from big to small as the shadow moves and creates a nice visual for the audience.

How's it done?

This shot is done in camera on set using creative lighting choices.

When should I use it?

This shot is best used in moments where you want to build the suspense and emphasize the weapon by casting its shadow on the wall. It works well in those slower moments where a character is investigating a noise or threat of something they are afraid of.

THE HOUSE OF THE DEVIL (2009)

Synopsis: In the 1980s, a college student takes a strange babysitting job that coincides with a full lunar eclipse. She slowly realizes her clients harbor a terrifying secret; they plan to use her in a satanic ritual.

Featured Scene: When the babysitter takes a kitchen knife and investigates strange noises coming from upstairs.

The House of the Devil (2009), directed by Ti West

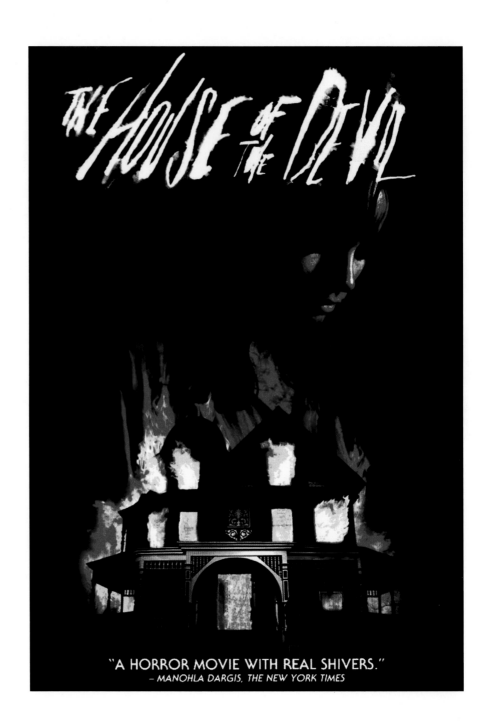

"A HORROR MOVIE WITH REAL SHIVERS."
– *MANOHLA DARGIS, THE NEW YORK TIMES*

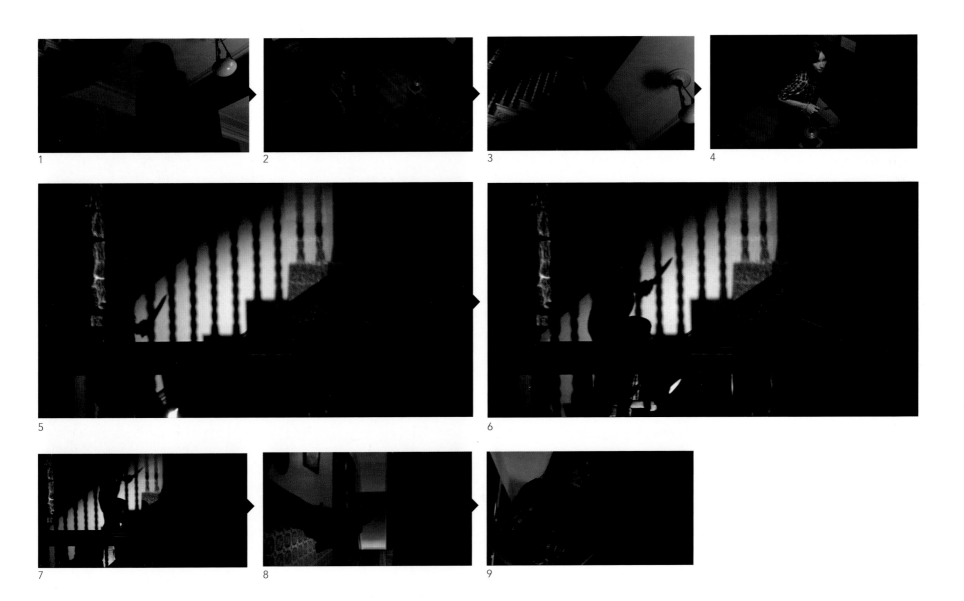

1

2

3

4

5

6

7

8

9

Jaws of Death

What does it look like?

This shot puts the camera inside of a person and/or creature's mouth. The shot usually has teeth in the foreground to emphasize the threat. The shot usually starts on black and opens to reveal a character that is about to be attacked or eaten.

How's it done?

This shot is a fake prosthetic mouth the camera shoots through on set.

When should I use it?

It works best on creature flicks. Use this shot during moments where you want to see the reaction of the character to the rows of razor sharp teeth.

FROM DUSK TIL DAWN 2 (1999)

Synopsis: Five misfit bank robbers led by Buck (Robert Patrick) head south of the border for the ultimate bank heist. But they get more than they bargained for when the motley crew stumbles into the notorious Titty Twister Bar with its blood-sucking clientele.

Featured Scene: At a seedy motel room, Luther (Duane Whitaker) visits Jesus (Raymon Cruz) and attacks him with his new vampire abilities.

From Dusk Til Dawn 2 (1999), directed by Scott Spiegel

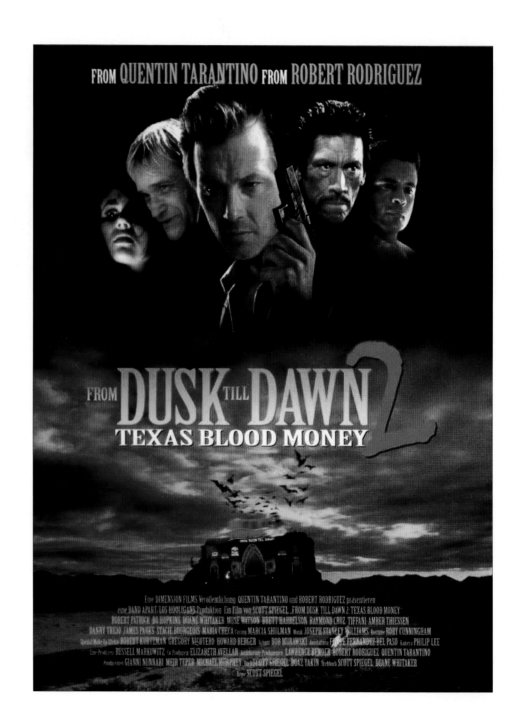

1

3

2

4

5

6

7

8

9

10

11

The Body Hole

What does it look like?

This shot takes the camera and aims it through a wound on the human body, usually a big one, and reveals the other side. The other side could be the shooter, a zombie, or a group of horrified onlookers.

How's it done?

This is mostly done as a CGI shot, but can also be done using practical makeup FX on set.

When should I use it?

This shot is best used to reveal the attacker or the object that created the hole. When the hole appears, there is usually a "rack focus" to resolve the shot to the background.

FINAL DESTINATION 4 (2009)

Synopsis: Young Nick O'Bannon (Bobby Campo) thinks he's cheated death when he keeps a grisly premonition from becoming reality, saving his friends and himself from being crushed in a catastrophic accident—but the survivors soon realize that fate has other plans.

Featured Scene: At the auto shop, one of the survivors gets a tank shot though his body, leaving a hole big enough to see through.

Final Destination 4 (2009), directed by David R. Ellis

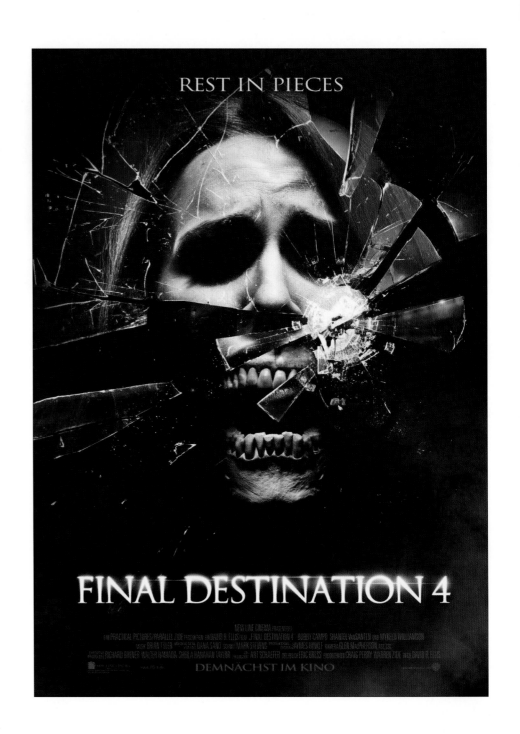

DOGHOUSE (2009)

Synopsis: A group of men head to a remote village to help one of their friends get over his divorce; when they get there, though, they discover that all the women have been infected with a virus that makes them man-hating cannibals.

Featured Scene: A group of friends find a survivor impaled on a fence, but he soon gets an axe through his skull by an angry zombie. This shot also has a nice rack focus that highlights the zombie's reaction.

Doghouse (2009), directed by Jake West

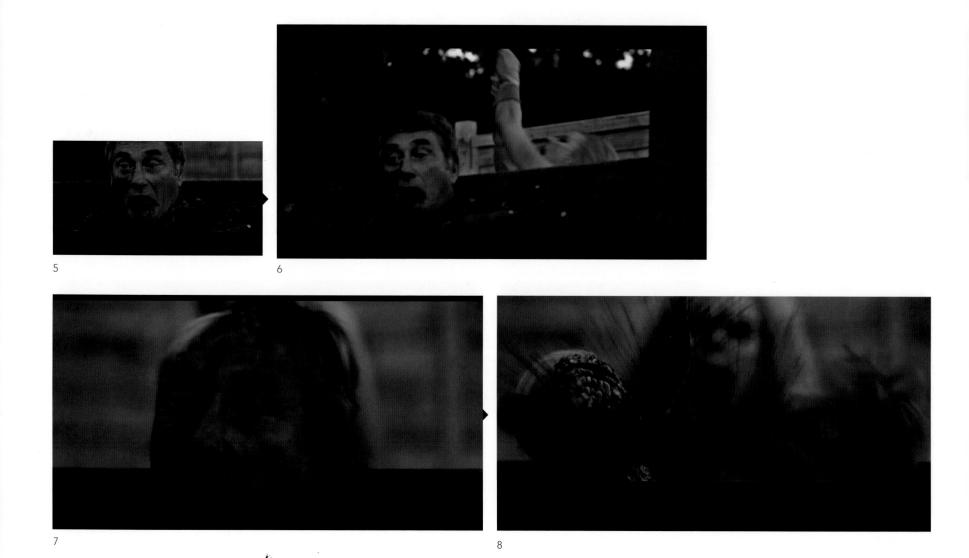

5

6

7

8

9

10

11

12

TEXAS CHAINSAW MASSACRE (2003)

Synopsis: A group of friends passing through are stalked and hunted down by a deformed killer with a chainsaw in order to sustain his poor family who can only afford to eat what they kill.

Featured Scene: In the van, a strange hitchhiker blows her brains out in front of everyone. This creates a massive hole in her head which the camera dramatically tracks through. A very unique shot.

Texas Chainsaw Massacre (2003), directed by Marcus Nispel

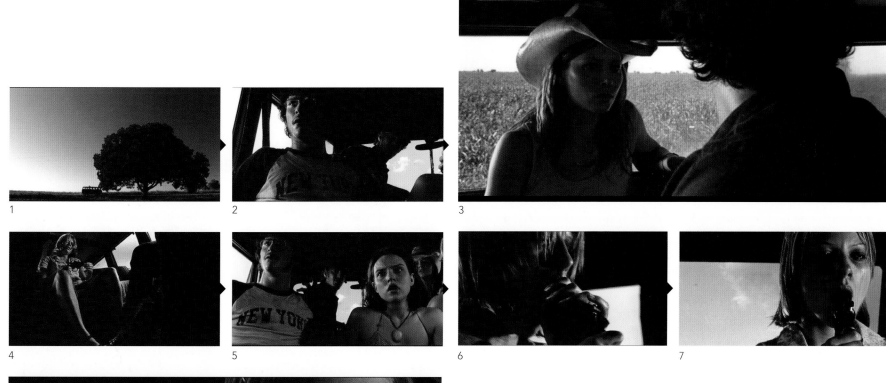

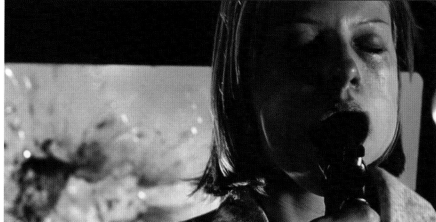

1

2

3

4

5

6

7

8

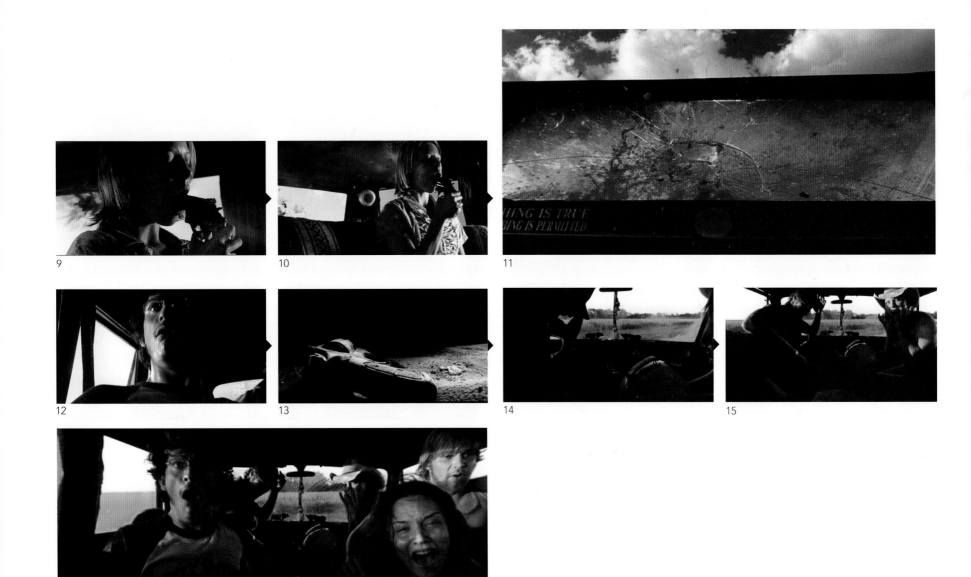

9

10

11

12

13

14

15

16

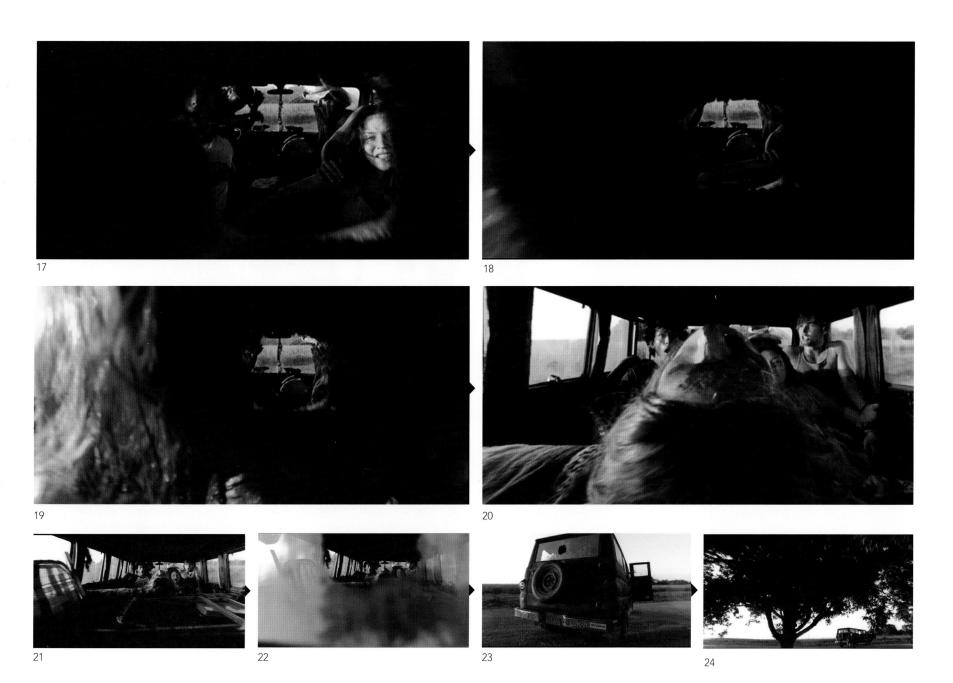

Danger at the Door

What does it look like?

It's any shot where the door is the only thing in between the character and the evil pursuing them. The shot is intensified by the door slowly being broken apart by an object (e.g., knife, axe) or a human until it is no longer safe to hide behind it.

How's it done?

This shot is done on set by carefully planning each impact so the actors are not hurt during filming.

When should I use it?

This shot is best used when you want to heighten the intensity of a pursuit or impending death. Since the door is the only thing between your character and the evil on the other side, it's a great way to prolong the terror.

CHILD'S PLAY (1988)

Synopsis: A single mother gives her son a beloved doll for his birthday; later they find out that the doll is possessed with the soul of a serial killer, who tries to put his soul into the boy's body in order to become human.

Featured Scene: A mother and son lock themselves in a bedroom to escape the wrath of Chucky, but he continues to attack them with his toy knife through the door.

Child's Play (1988), directed by Tom Holland

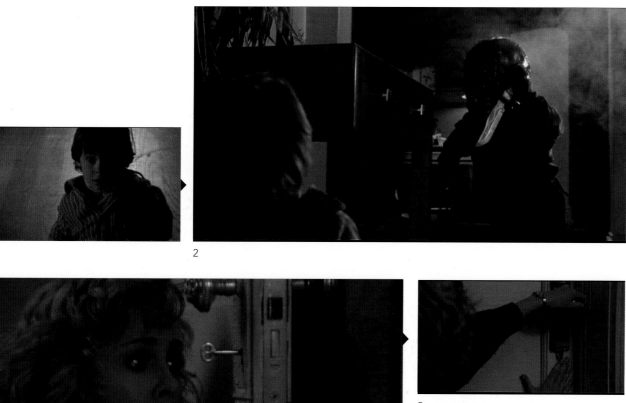

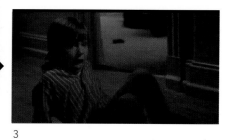

1

2

3

4

5

6

7

8

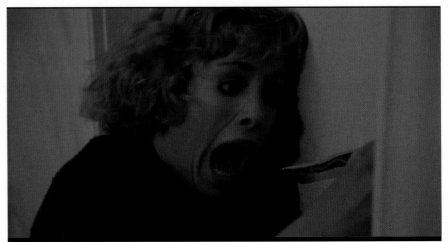

9

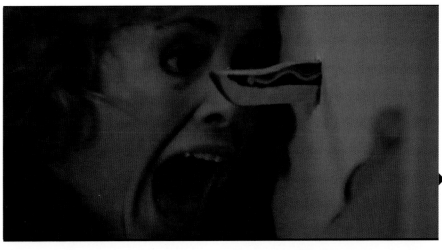

10

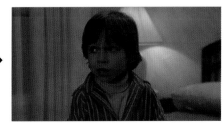

11

12

14

13

THE BROOD (1979)

Synopsis: A man tries to uncover an unconventional psychologist's therapy techniques on his institutionalized wife, while a series of brutal attacks committed by a brood of mutant children coincides with the husband's investigation.

Featured Scene: A young girl is attacked by a brood of mutant children through a door.

The Brood (1979), directed by David Cronenberg

1

2

3

4

5

6

7

8

9

10

11

12

Lurking From Above

What does it look like?

This is a shot where the audience sees a creature lurking above the character, but the character is unaware of the threat.

How's it done?

This shot is done as CGI.

When should I use it?

This shot can be used when you want the audience to be on the edge of their seats. It's unsettling for the audience to see a character in danger but the character is unaware of it.

THE EXORCIST 3 (1990)

Synopsis: A police lieutenant in Georgetown mourns the anniversary of a priest's death as a serial killer strikes.

Featured Scene: During a hospital visit, Kinderman (George C. Scott) walks through a hospital ward where one of the patients walks across the ceiling.

The Exorcist 3 (1990), directed by William Peter Blatty

1

2

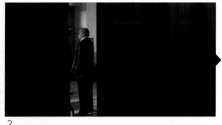

3

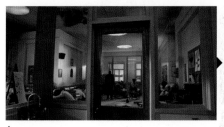

4

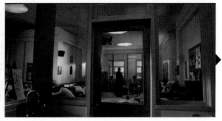

5

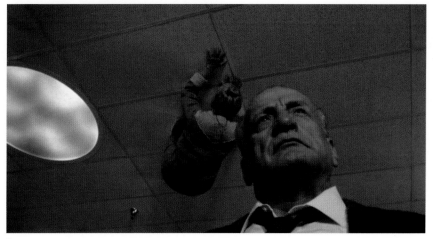

6

 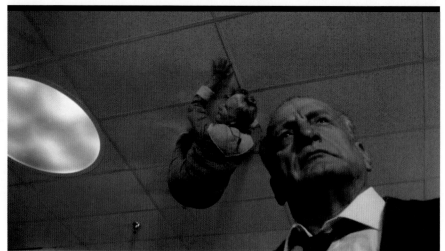

7 8

9

10

The Voyeur

What does it look like?

It's a shot that shows the POV of a killer and/or monster watching its prey. It's also common to see a hand appear in the foreground or even a POV behind a mask.

How's it done?

This shot is done on set and using the handheld camera technique.

When should I use it?

It's best to use this shot in moments where you want the audience to be in the shoes of the killer or creature as it stalks its prey.

FRIDAY THE 13TH (1980)

Synopsis: Camp counselors are stalked and murdered by an unknown assailant while trying to reopen a summer camp that was the site of a child's drowning.

Featured Scene: When the kids take a dip in the lake we see someone is watching in the woods.

Friday The 13th (1980), directed by Sean S. Cunningham

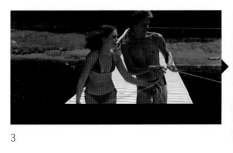

1

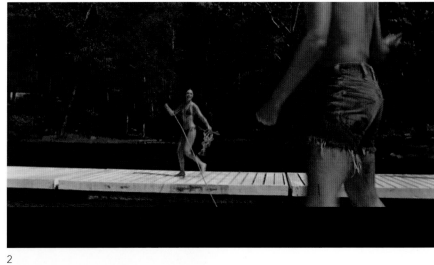

2

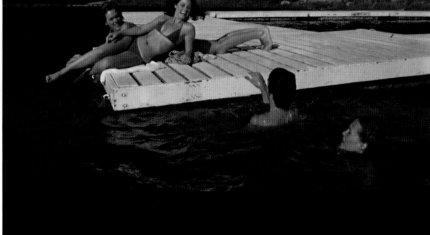

3

4

5 6

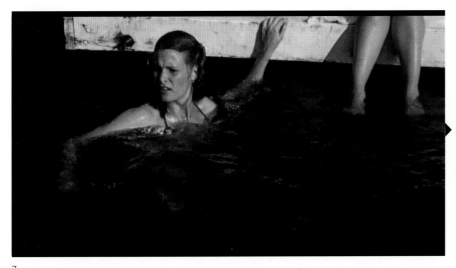

7

8

The Monster Inside

What does it look like? It's any shot or sequence that reveals to the audience some inhuman or supernatural feature of the antagonist, but is not revealed to the character, at least not right away.

How's it done? This is done as a practical makeup shot on set.

When should I use it? You should use this shot when you want your audience to know of a threat before the protagonist in the film knows of it.

HELLRAISER 2 (1988)

Synopsis: Kirsty is brought to an institution after the death of her family, where the occult-obsessive head resurrects Julia and unleashes the Cenobites once again.

Featured Scene: In the attic, Julia (Clare Higgins) lures her last man into her den of evil in order to steal his life force and repair her skinless body.

Hellraiser 2 (1988), directed by Tony Randel

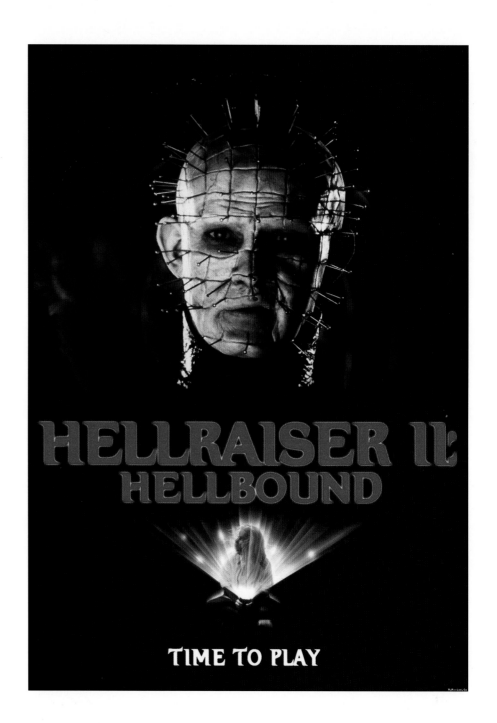

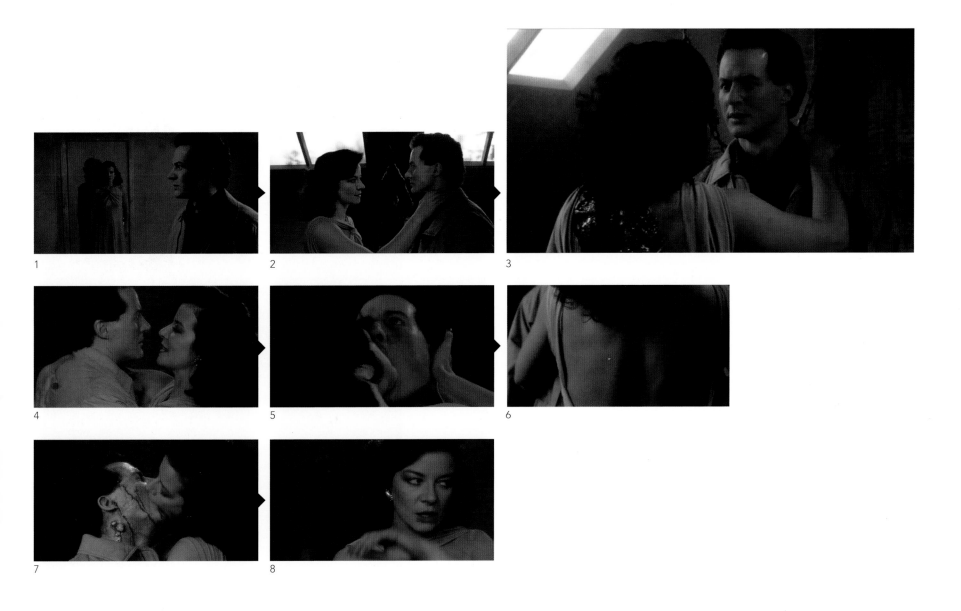

1

2

3

4

5

6

7

8

THE SHINING (1980)

Synopsis: A family heads to an isolated hotel for the winter where an evil and spiritual presence influences the father into violence, while his psychic son sees horrific forebodings from the past and of the future.

Featured Scene: Jack Torrance (Jack Nicholson) is drawn into a mysterious room where he has a supernatural encounter with a beautiful woman who turns into a corpse.

The Shining (1980), directed by Stanley Kubrick

1

2

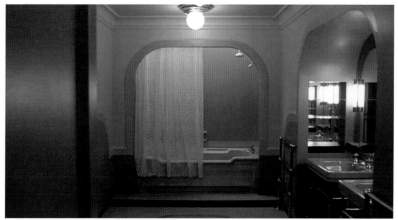

3

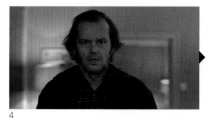

4

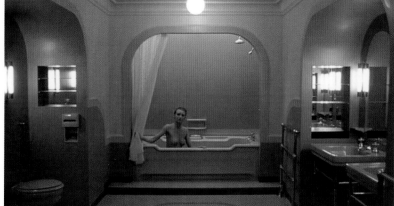

5

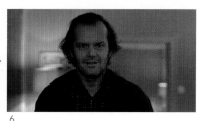

6

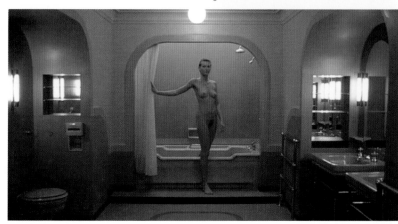

7

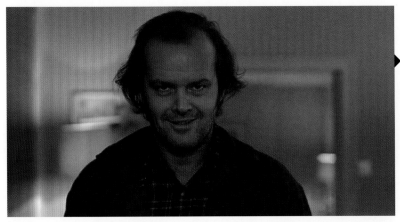

8

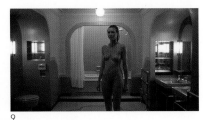

9

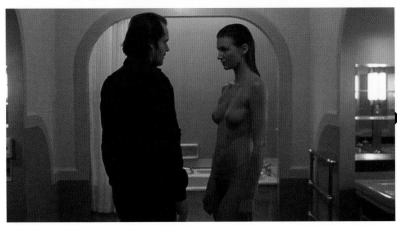

10

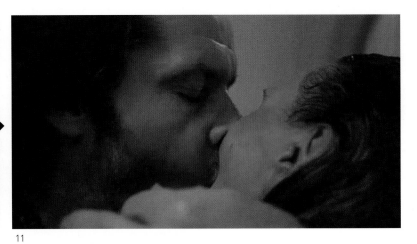

11

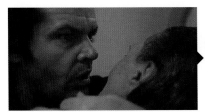

12

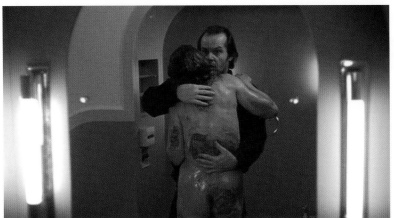

13

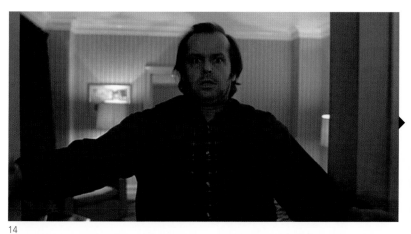

14

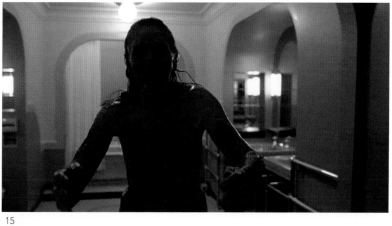

15

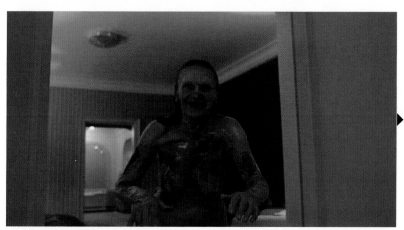

16

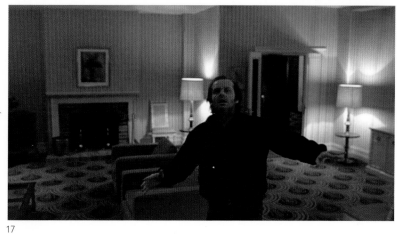

17

18

19

Deadly Weapon Tracking Shot

What does it look like? This shot follows the path and motion of a weapon as it approaches a character. It could be a knife or axe thrown at someone, or a bullet shot from a gun.

How's it done? This shot can be done on set using a special rig for the object, or more commonly it is done as a CGI effect. It's common to slow this shot down to prolong the time, but return to real time on impact.

When should I use it? You can use this shot when you want to draw attention to the weapon, its unique motion path, and the deadly impact that is imminent.

MY BLOODY VALENTINE (2009)

Synopsis: Tom returns to his hometown on the tenth anniversary of the Valentine's night massacre that claimed the lives of 22 people. Instead of a homecoming, however, Tom finds himself suspected of committing the murders, and it seems like his old flame is the only one who believes he's innocent.

Featured Scene: During a daring escape the killer throws his axe at the kids in the truck and the camera follows the weapon until impact.

My Bloody Valentine (2009), directed by Patrick Lussier

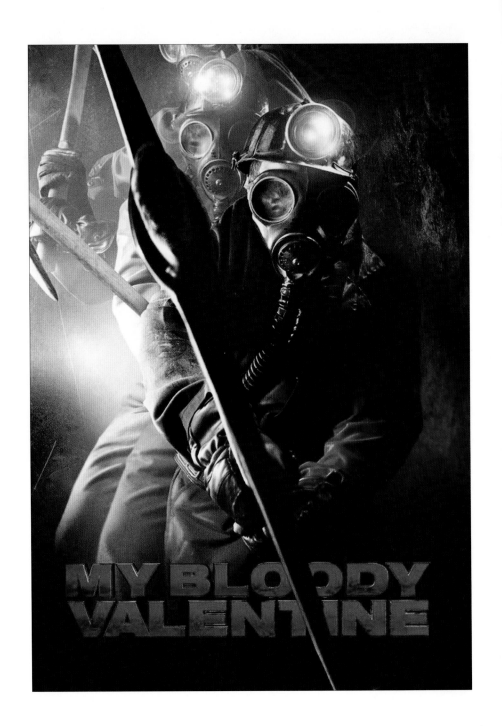

1

2

3

4

5

6

7

8

9

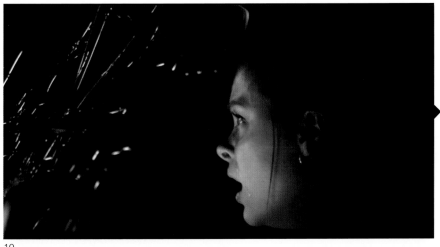

10

11

12

SCREAM 3 (2000)

Synopsis: Ghostface pays Sidney and her friends a third visit while they visit the set of "Stab 3", the third movie based upon the Woodsboro murders.

Featured Scene: Dewey (David Arquette) tries to shoot Ghostface in the stairwell but runs out of bullets. Ghostface throws his knife at him and the camera tracks with the knife as it spins in a circular motion until it hits him in the head.

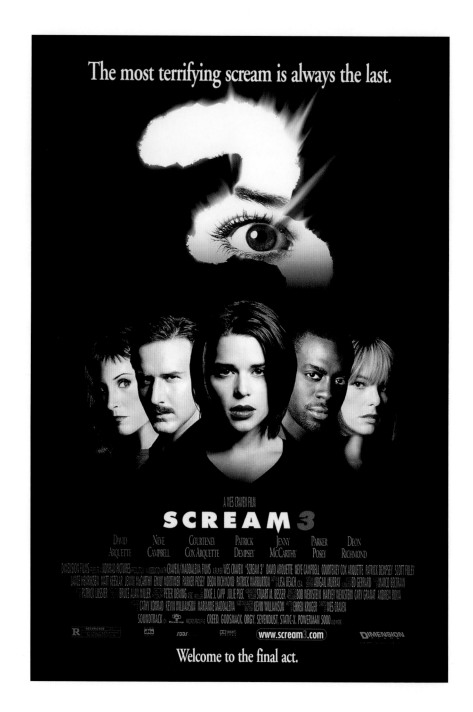

Scream 3 (2000), directed by Wes Craven

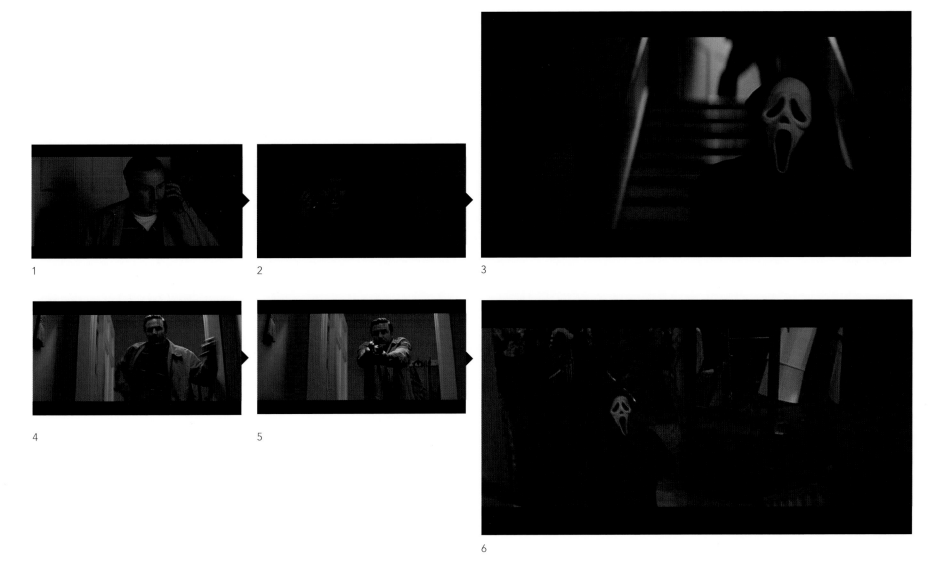

1

2

3

4

5

6

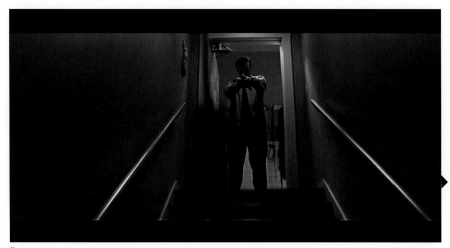

7

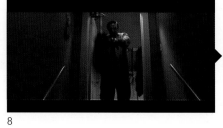

8

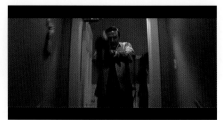

9

10

11

12

13

14

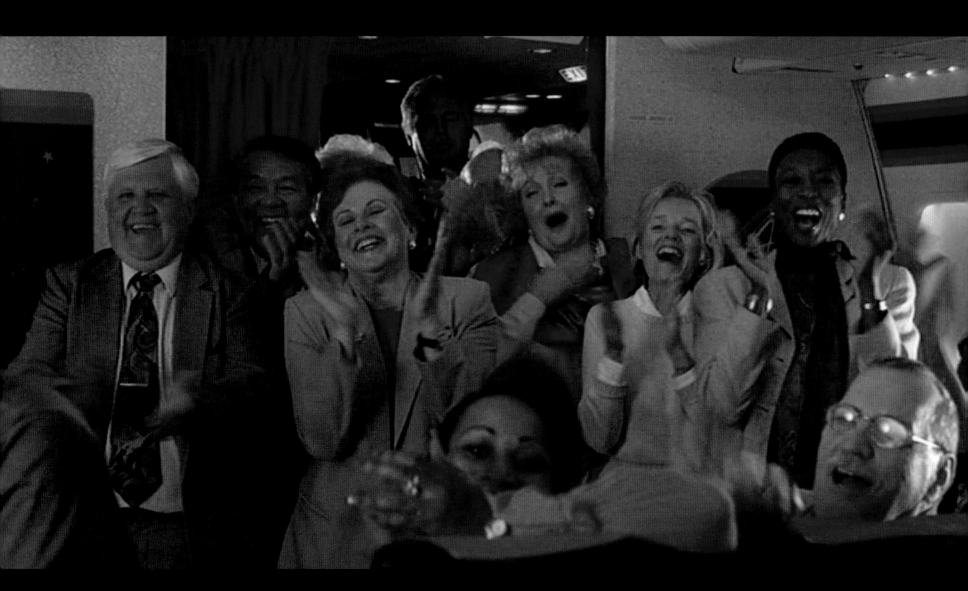

The Comedy
Genre

Comedy | a play, movie, etc., of light and humorous character with a happy
or cheerful ending; a dramatic work in which the central motif is the triumph
over adverse circumstance, resulting in a successful or happy conclusion.

The Seduction Shot

What does it look like?

It's any shot that uses creative framing to show a sexy moment or seduction.

How's it done?

It's accomplished by having one character in the foreground (soft focus) and another character that watches in the background.

When should I use it?

It's best to use this in moments where you want to create a sexual tension between two characters. The tension is heightened by the separation of foreground and background space. It can also be used as a voyeur shot.

THE GRADUATE (1967)

Synopsis: Recent college graduate Benjamin Braddock is trapped into an affair with Mrs. Robinson, who happens to be the wife of his father's business partner and then finds himself falling in love with her daughter, Elaine.

Featured Scene: In the bedroom, Mrs. Robinson sits on the bed and seductively puts on her stockings as Benjamin watches.

The Graduate (1967), directed by Mike Nichols

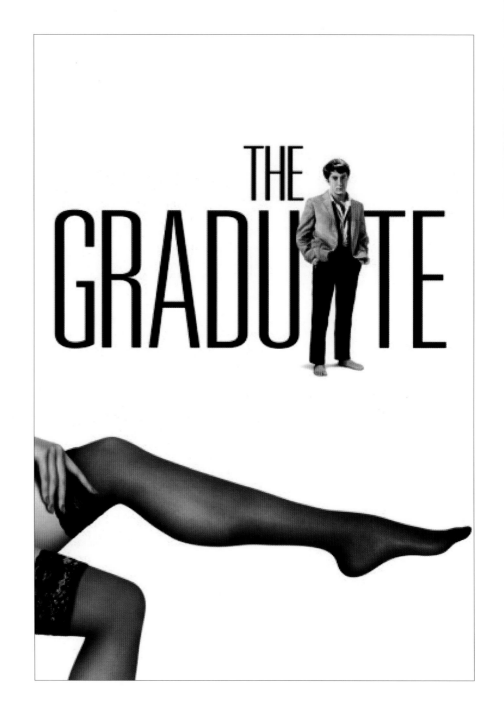

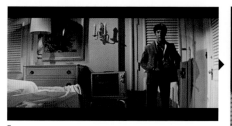

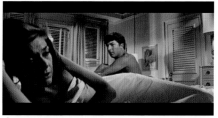

1

2

3

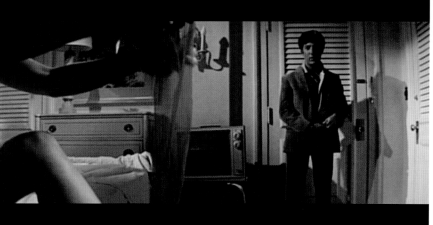

4

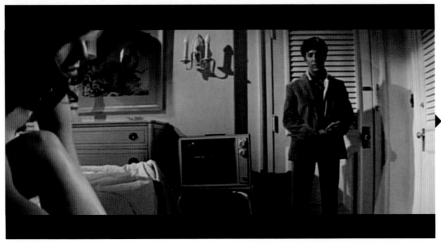

5

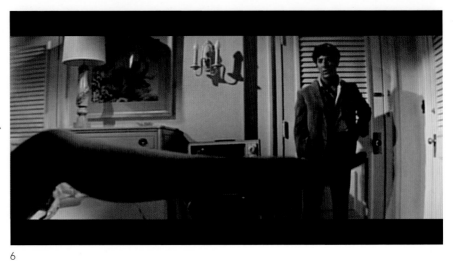

6

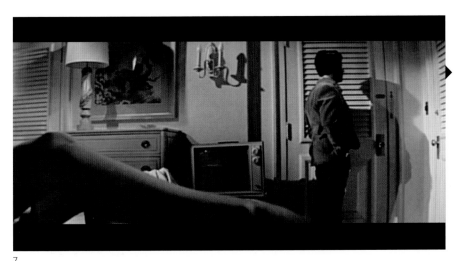

7

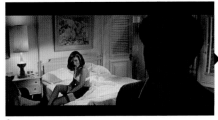

8

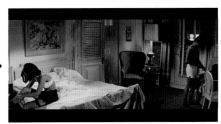

9

The Lustful Gaze

What does it look like?

It's a sequence that draws special attention to a body part or other object that the character is lusting over by using a moving camera as the POV.

How's it done?

It's usually two shots: One shot pushes into the character's face as he sees something or someone he wants, the other is the reverse as that person walks to the character. As the person gets close enough his gaze is revealed to the audience, usually for comic effect or emphasis.

When should I use it?

Use it for comic effect.

BACHELOR PARTY (1984)

Synopsis: A soon-to-be-married man's friends throw him the ultimate bachelor party.

Featured Scene: A lustful department store clerk sees a beautiful and busty woman approaching him and his eyes fixate on her breasts.

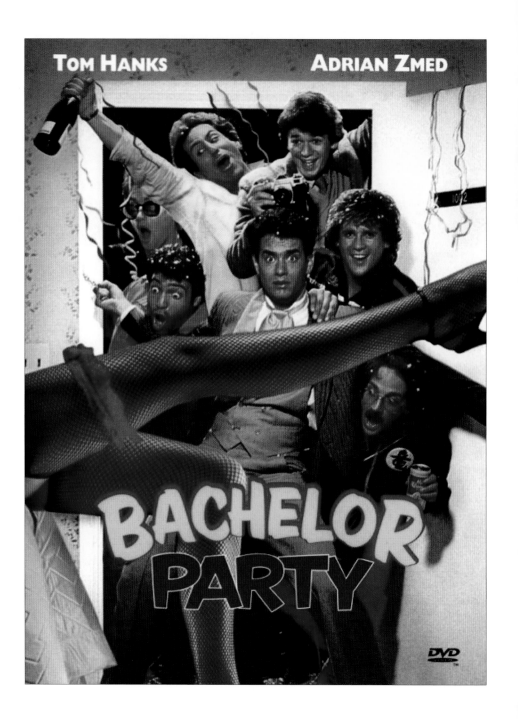

Bachelor Party (1984), directed by Neal Israel

1

2

3

4

5

6

7

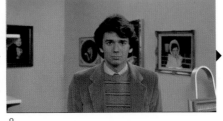

8

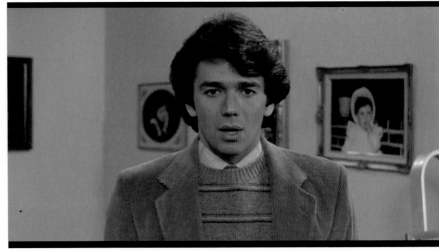

9

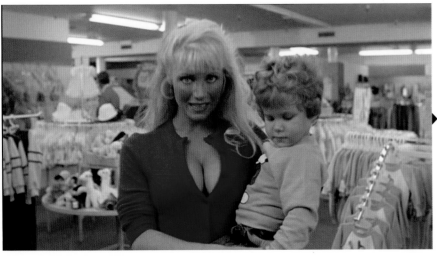

10

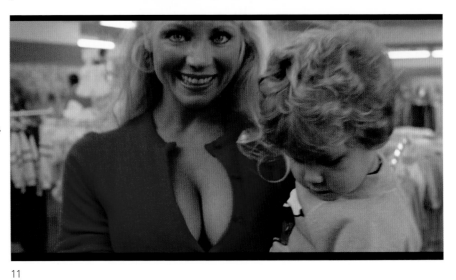

11

12

13

The Floating Camera

What does it look like?

It's a shot that seems to float from one side of the table to the other during a conversation. Each turn of the camera favors who is talking at the time.

How's it done?

This shot is done with a dolly or Steadicam rig. It needs to be timed with the actors' dialogue for maximum effect.

When should I use it?

Use it for style and to keep a normally boring conversation at a table more dynamic. It also redirects the audience's attention to each individual and keeps the dialogue more intimate.

ABOUT A BOY (2002)

Synopsis: Based on Nick Hornby's best-selling novel, *About A Boy* is the story of a cynical, immature young man who is taught how to act like a grown-up by a little boy.

Featured Scene: Will Freeman (Hugh Grant) has dinner and conversation with a woman in a restaurant about children.

About a Boy (2002), directed by Chris Weitz and Paul Weitz

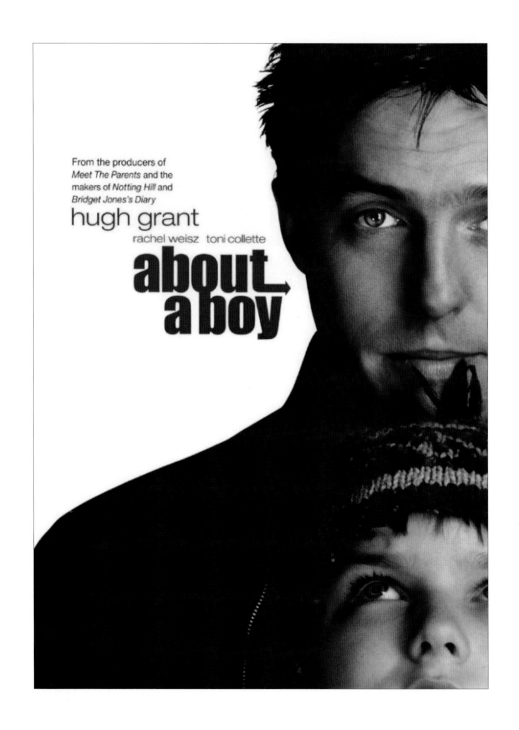

From the producers of *Meet The Parents* and the makers of *Notting Hill* and *Bridget Jones's Diary*

hugh grant

rachel weisz toni collette

about a boy

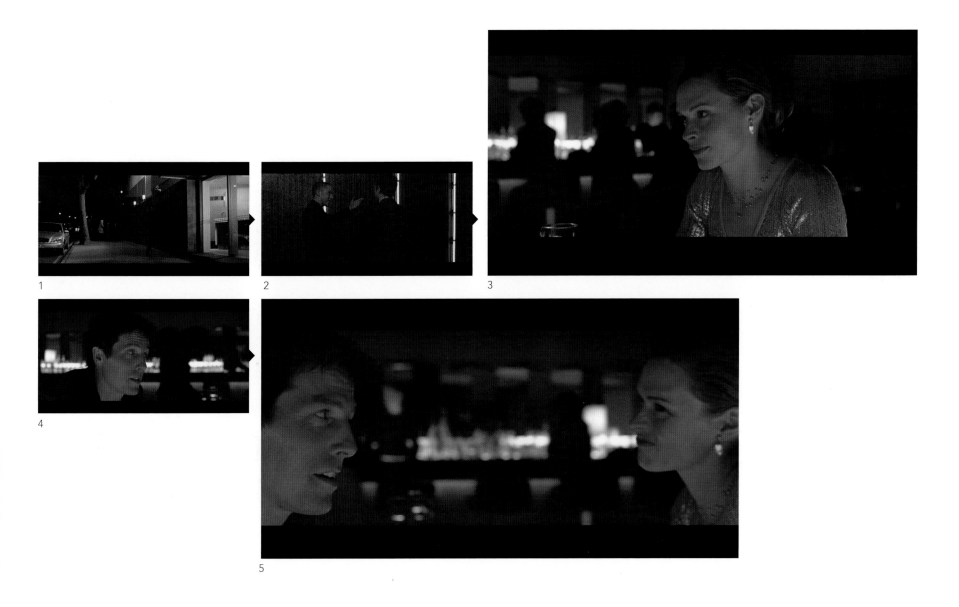

1

2

3

4

5

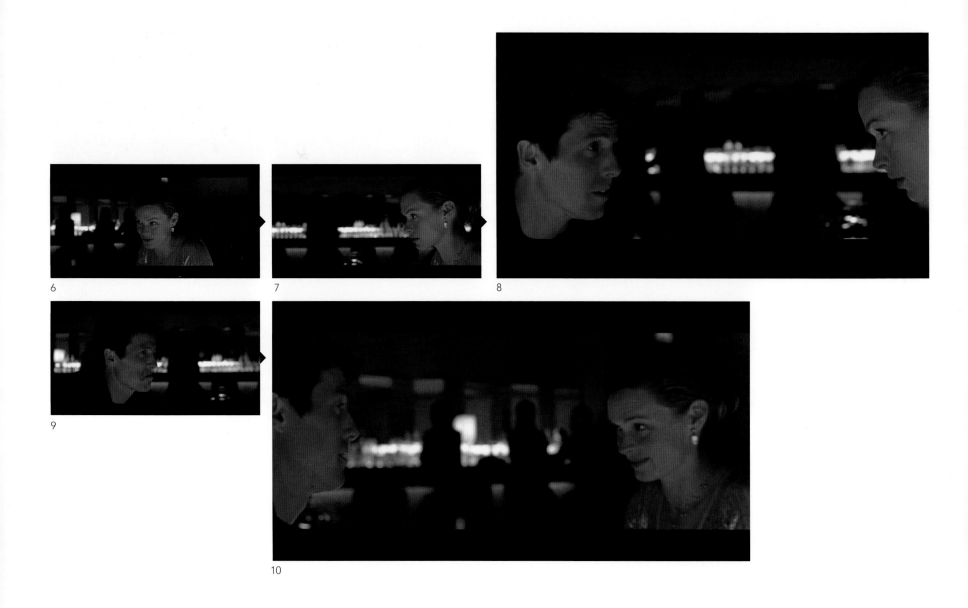

6

7

8

9

10

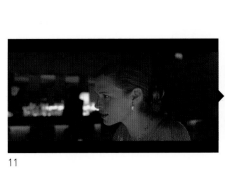

11

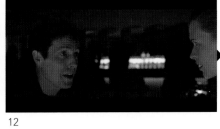

12

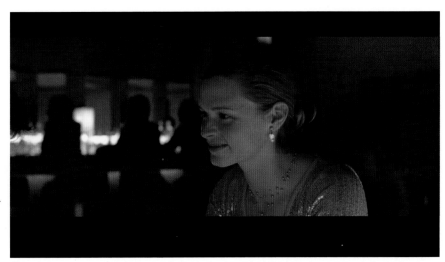

13

Slow and Sexy Body Reveal

What does it look like?

The shot usually starts on the feet and slowly tilts up to the face to reveal the character.

How's it done?

It is just a simple tilt up or down of the camera. You can prolong the moment by shooting it in slow motion as the character poses.

When should I use it?

This shot is best used to prolong a sexually charged moment. They could be scantily clad or just look stunning in a new dress.

WEIRD SCIENCE (1985)

Synopsis: Two nerdish boys attempt to create the perfect woman, but she turns out to be more than that.

Featured Scene: When Gary and Wyatt's wild experiment is successful, a gorgeous woman appears at the door.

Weird Science (1985), directed by John Hughes

1

2

3

4

5

6

7

8

9

10

11

12

13

14

15

The Surreal 360 Kiss

What does it look like?
It's a shot that slowly circles around two characters kissing.

How's it done?
It's done by using a dolly or steadicam rig and a long lens.

When should I use it?
This shot should not be used on just any kiss. It's that "special" kiss or embrace where you should prolong the moment for the audience. It's often seen at the end of the film and is always a happy moment.

SERENDIPITY (2001)

Synopsis: Though strangers Sara Thomas (Kate Beckinsale) and Jonathan Trager (John Cusack) are already in relationships, they realize they have genuine chemistry after a chance encounter—but they soon part company. Years later, they yearn to reunite despite being destined for the altar.

Featured Scene: At the end of the film at the ice skating rink the lovers embrace.

Serendipity (2001), directed by Peter Chelsom

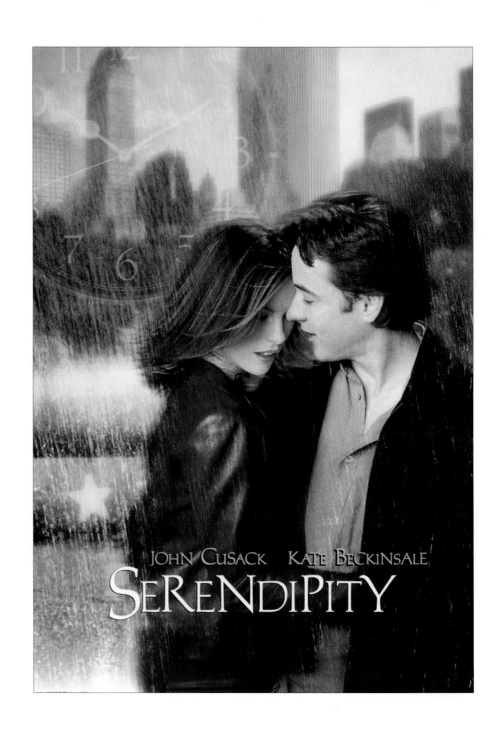

JOHN CUSACK KATE BECKINSALE

SERENDIPITY

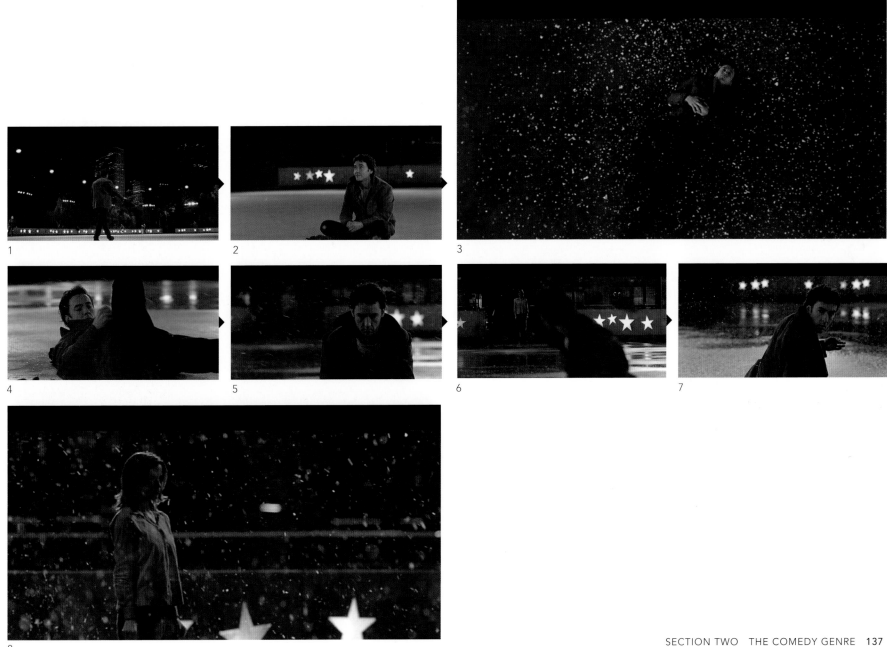

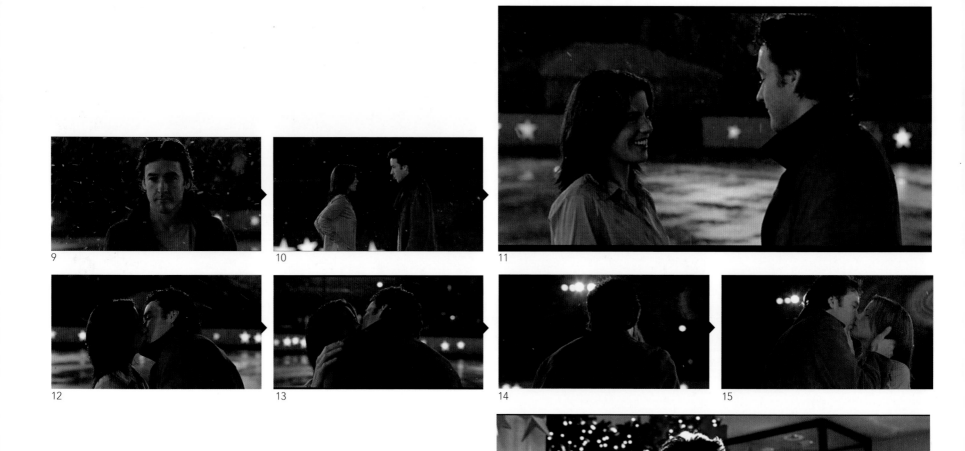

This shot starts in the ice rink then the kiss continues one year later on their anniversary. This is also a nice transition moment in this film.

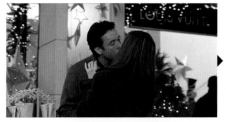

17

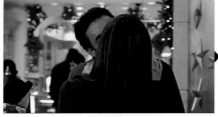

18

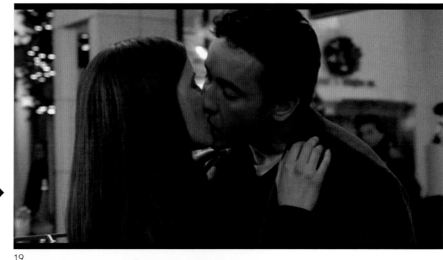

19

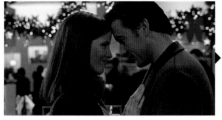

20

21

Split Screen

What does it look like?
It's any shot that splits the screen to show two or more additional scenes playing out.

How's it done?
It's done in the editing and there are many creative ways to present the framing on screen.

When should I use it?
It works well when a character is talking directly to the audience about something comedic. It can show the viewer what he is talking about in the present day, the past, or future.

SAVING SILVERMAN (2001)

Synopsis: In this rollicking comedy, a pair of clueless losers conspires to prevent their hapless buddy from marrying a shrewish shrink by abducting her and setting him up with his long-lost love—who's soon to be a nun.

Featured Scene: In the beginning of the film Wayne (Steve Zahn) describes his High School friends to the audience.

Saving Silverman (2001), directed by Dennis Dugan

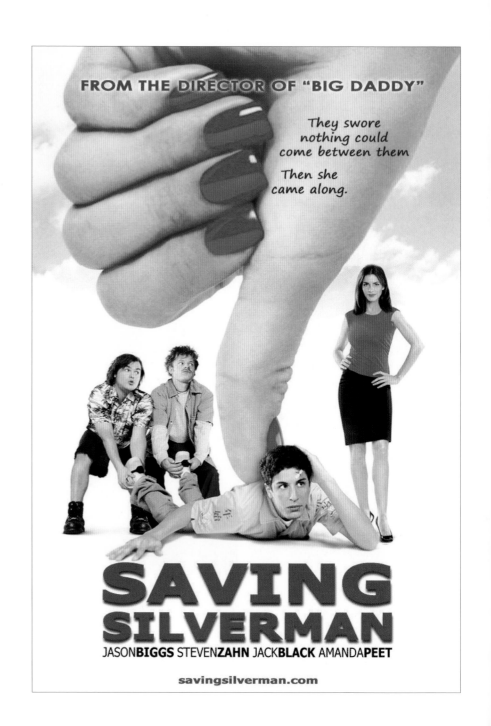

1

2

3

4

5

6

7

8

9

10

In this film, the split screen window on the right acts as a flashback to show the audience his high school days.

The Imagined Self

What does it look like?
It's any shot where a character appears in a reflection and his/her body is superimposed upon an object (like clothing) or reflected alongside another object of desire.

How's it done?
This shot is photographed on set using creative lighting to create a reflection on glass.

When should I use it?
This shot is best used when you want a character to imagine himself/herself in a way that inspires them into acting upon their desires.

THE TERMINAL (2004)

Synopsis: An eastern immigrant finds himself stranded in JFK airport, and must take up temporary residence there.

Featured Scene: Viktor (Tom Hanks) looks into a shop window at clothes.

The Terminal (2004), directed by Steven Spielberg

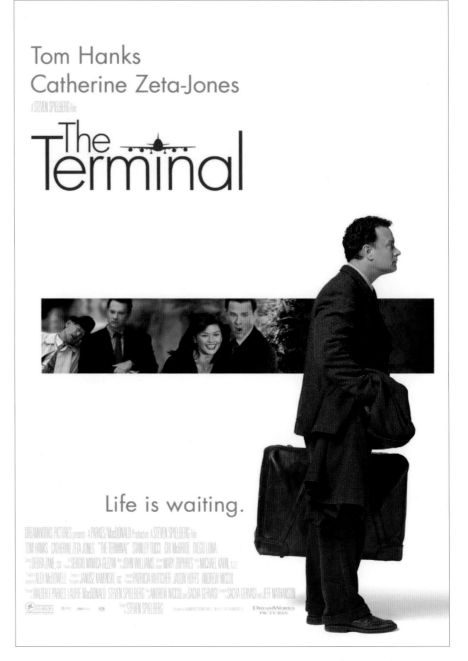

1

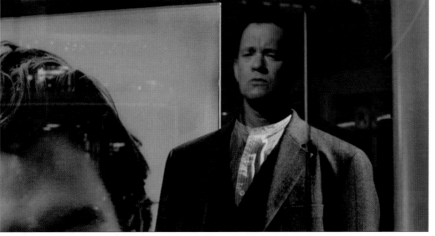

2

3

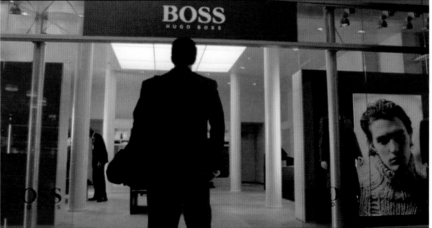

4

5

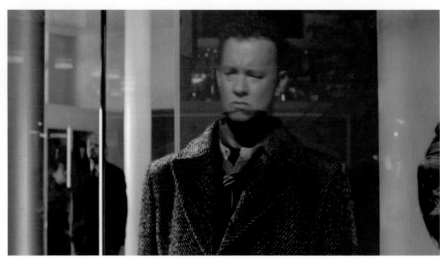

6

7

8

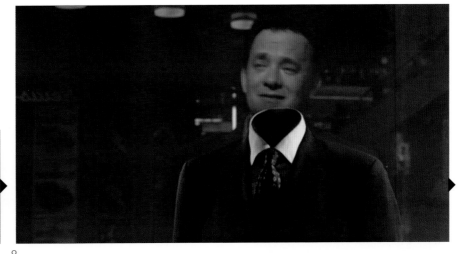

9

10

11

The Marriage Transition

What does it look like?

This shot features the camera slowly pushing into a kiss then cutting into a tight shot of a similar framing. The kiss continues as the camera pulls back revealing they have just got married.

How's it done?

It's done using a dolly track or Steadicam.

When should I use it?

It should be used when you want to show a time passage from first kiss to walking down the aisle together.

THE WEDDING SINGER (1998)

Synopsis: Wedding band front man Robbie Hart (Adam Sandler) anxiously awaits his marriage to his longtime girlfriend. But when Robbie gets jilted at the altar, a reception-hall waitress (Drew Barrymore) tries to end his heartbreak by enlisting his expertise in planning her wedding.

Featured Scene: At the end of the film when Robbie kisses Julia on the plane we match cut to them kissing at the altar.

The Wedding Singer (1998), directed by Frank Coraci

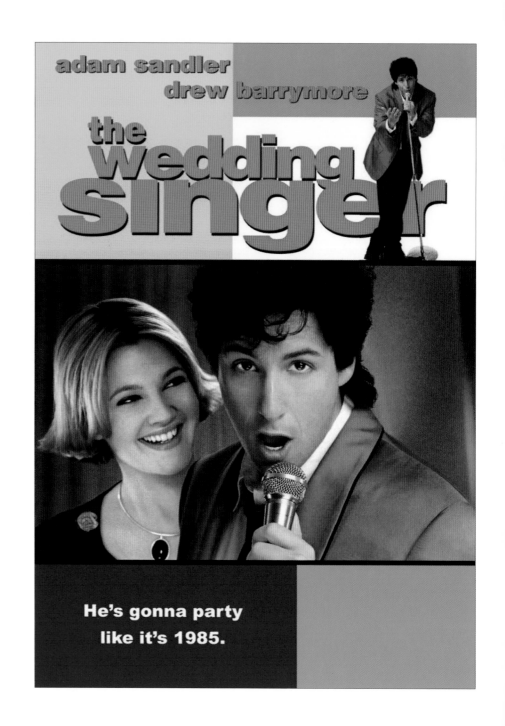

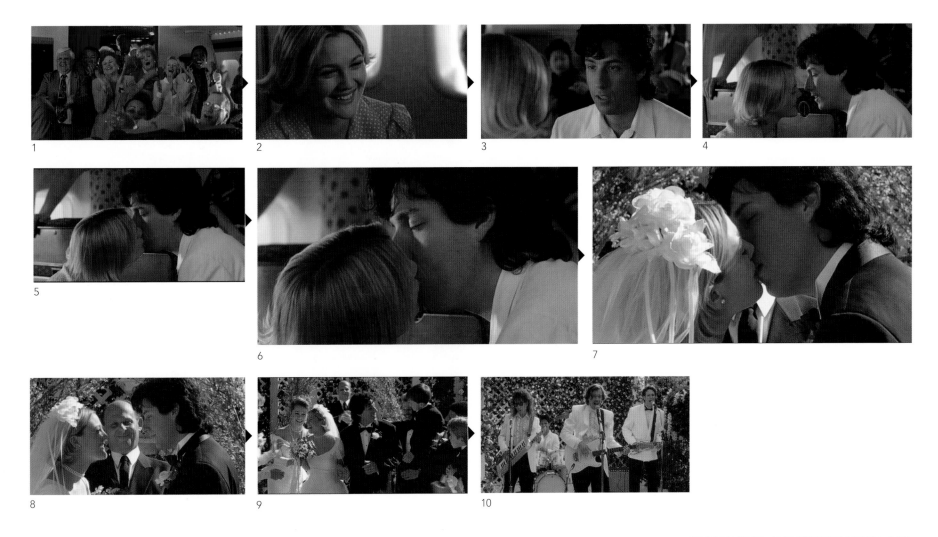

Dual Scenes Sequence

What does it look like?

It's a split screen shot that simply lets the audience watch two scenes happening at the same time within the framing of one shot on screen.

How's it done?

It's done in the editing by cutting two real-time scenes together and playing them in the framing of one split screen shot.

When should I use it?

It's a stylized approach you could use when you want to show two events happening simultaneously on screen. It's best if these events meet up at some point and have an on-screen resolution.

THE RULES OF ATTRACTION (2002)

Synopsis: Set at an affluent liberal arts college, this comedy offers a sardonic look at an emerging sexual triangle between co-eds Sean, a part-time drug dealer; Paul, who's bisexual and has a crush on Sean; and Lauren, Paul's ex-girlfriend.

Featured Scene: As Lauren and Sean head to campus the screen splits into two frames and shows two scenes playing simultaneously. This series of events leads to the two meeting in the hallway in which the split screen wonderfully resolves back into a master two-shot.

The Rules of Attraction (2002), directed by Roger Avary

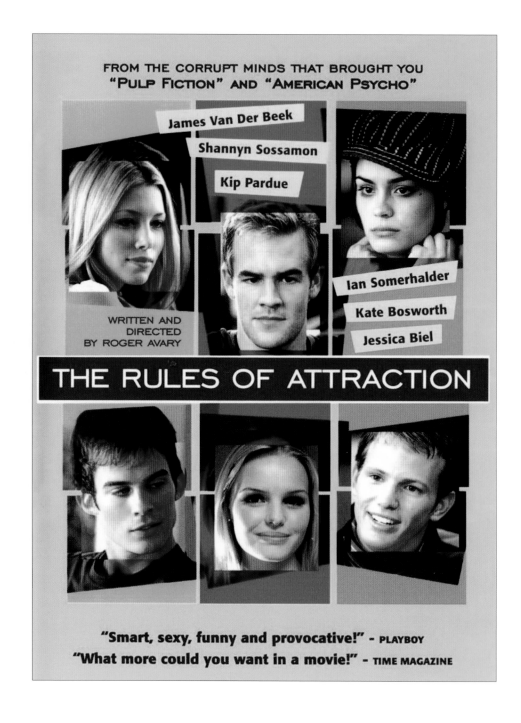

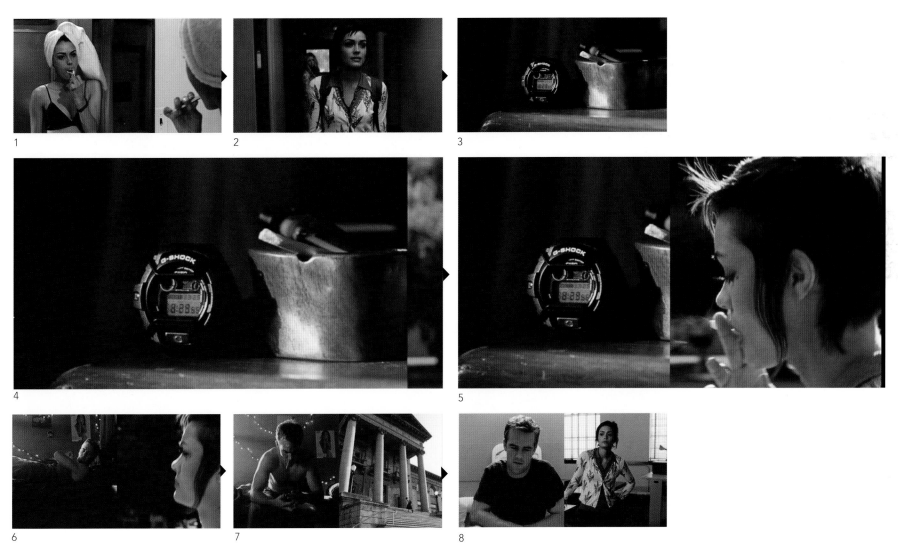

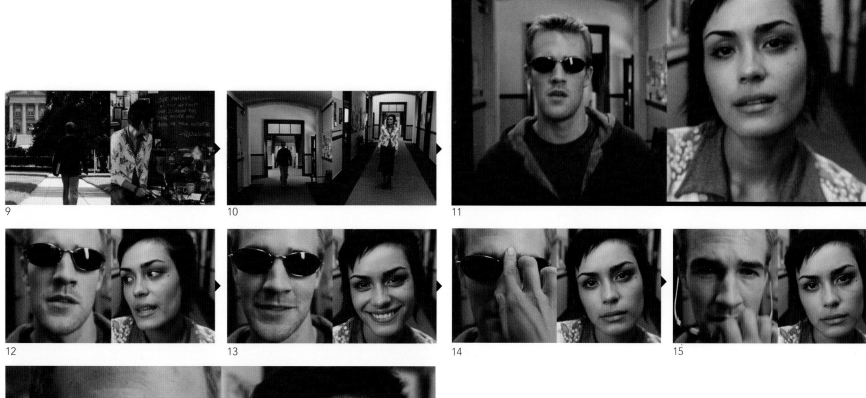

9

10

11

12

13

14

15

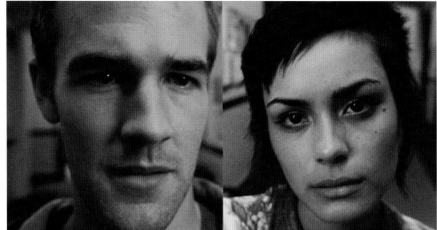

16

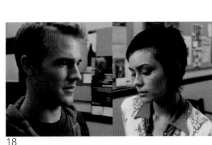

17

18

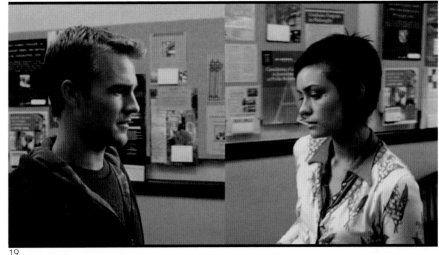

19

20

21

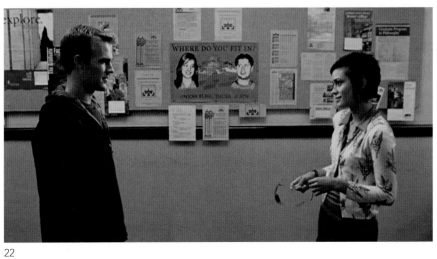

22

23

24

The Changing Seasons Sequence

What does it look like?

It's a prolonged tracking shot that follows a character during a time passage in his/her life as seen by visual cues in the shot. It appears as one very long continuous shot on screen.

How's it done?

It's a long tracking shot that creatively hides a few edits along the way.

When should I use it?

It's a wonderful way to show time passage by only giving the audience visual cues within the shot.

NOTTING HILL (1999)

Synopsis: A chance encounter brings together reserved bookstore owner William Thacker (Hugh Grant) and Hollywood icon Anna Scott (Julia Roberts), who forge an improbable romance until Anna's megastardom begins whittling away at their relationship.

Featured Scene: William walks the streets back to his bookstore as the seasons of the year change around him.

Notting Hill (1999), directed by Roger Michell

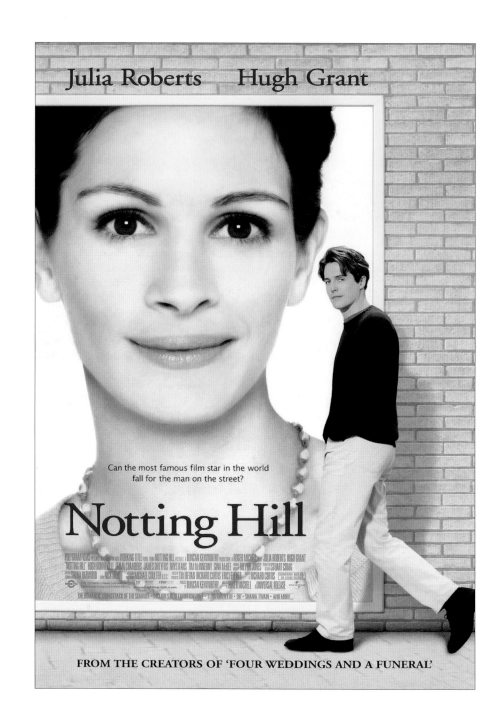

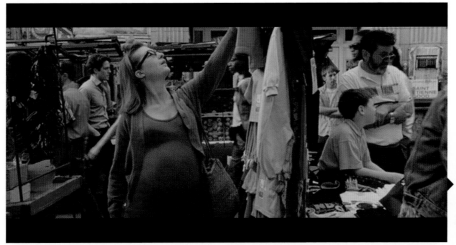

1

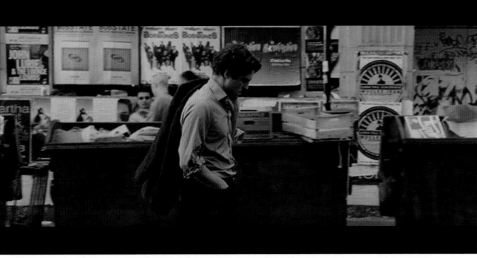

2

3

4

5

Camera tracks from left to right for the entire sequence. The beginning of the shot shows a woman who is pregnant
and by the end of the walk she has the baby in her arms. A wonderful visual sequence.

6

7

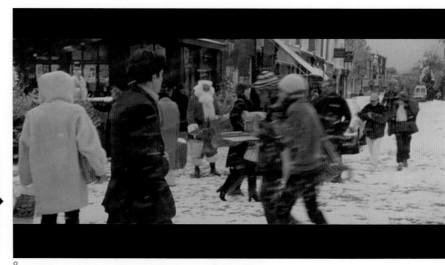

8

9

10

11

12

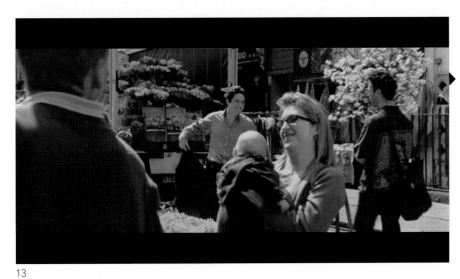

13

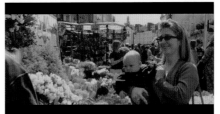

14

Multiple Dates 360

What does it look like?

This shot uses the camera to spin around a table during a series of dates with multiple people. It's very stylized.

How's it done?

It's a circular dolly shot that creatively hides the editing when objects pass in front of the frame. It can also be shot in fast motion for added effect.

When should I use it?

It's best to use this to show a time passage happening in the same location over a period of months. It's also very effective in showing the frustrated life of a character trying to find that special someone.

MY SASSY GIRL (2008)

Synopsis: After shy Midwesterner Charlie Bellow (Jesse Bradford) saves the wild Jordan Roark (Elisha Cuthbert) from falling to her death, he gets an instant vacation from his risk-averse, surprise-free lifestyle when the carefree beauty woos him. Jordan puts Charlie through the emotional ringer, until a dark secret from her past threatens to crush their courtship.

Featured Scene: In the restaurant when Charlie is on a date the camera spins around the table taking us from February to December.

My Sassy Girl (2008), directed by Yann Samuell

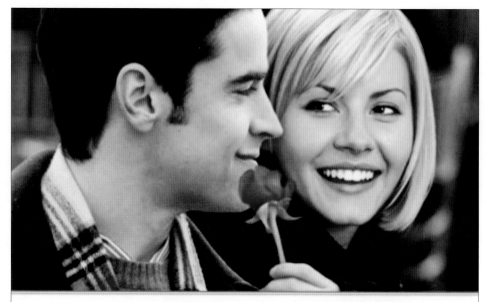

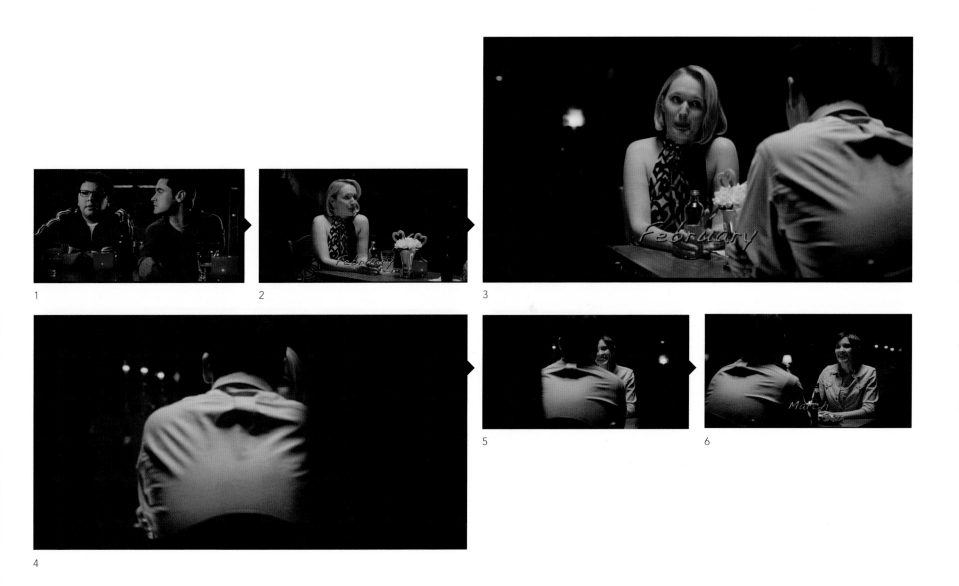

Camera does a 360 spin around the table (left to right).

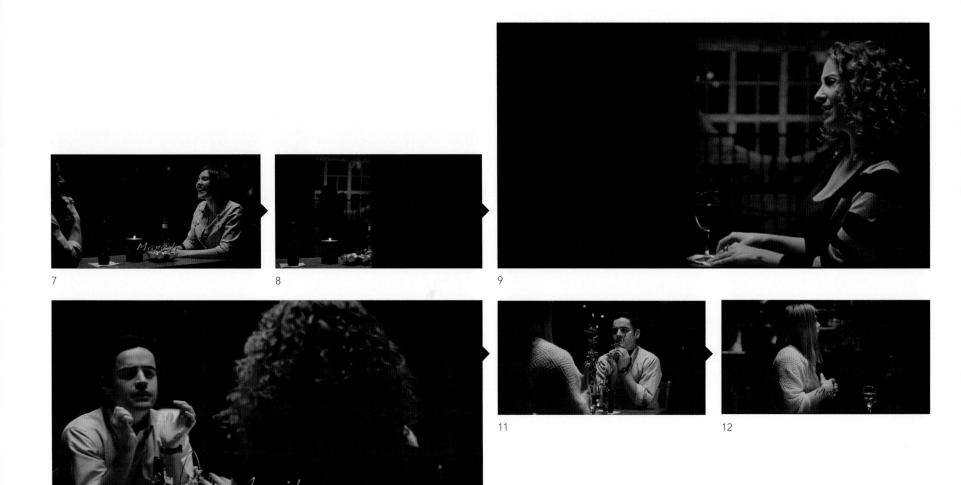

7

8

9

10

11

12

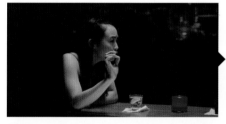
13

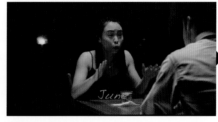
14

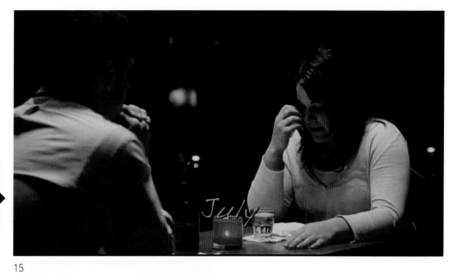
15

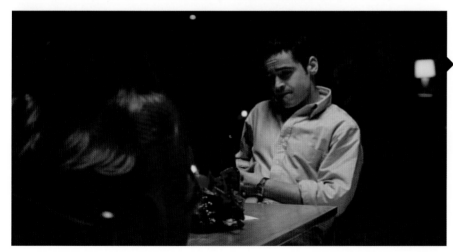
16

17

SECTION TWO THE COMEDY GENRE 159

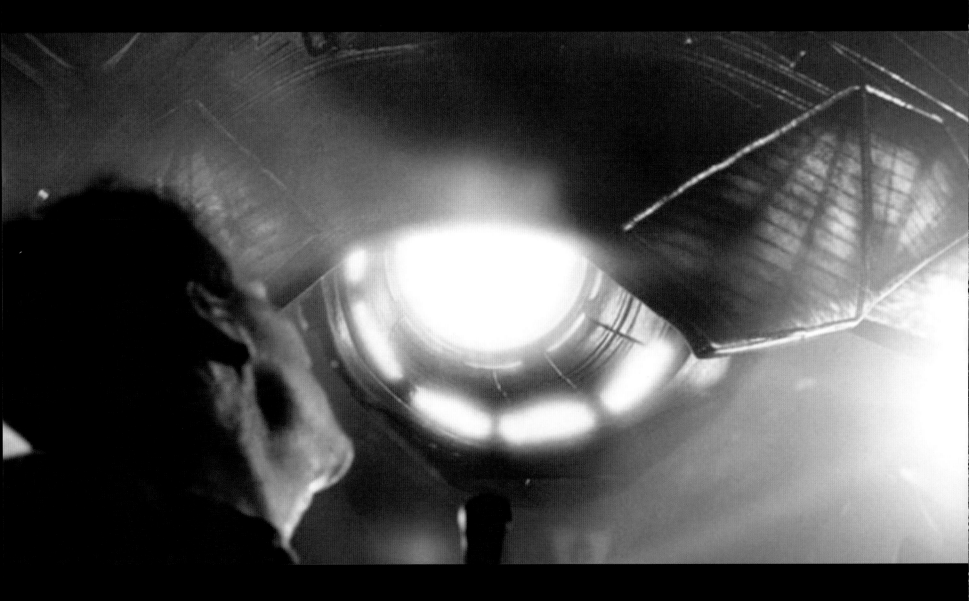

The Sci-Fi Genre

Science-Fiction | A genre of fiction dealing principally with the impact of actual or imagined science on society or individuals or having a scientific factor as an essential orienting component.

The Surprise Attack

What does it look like?

It's an unexpected moment in which a character is suddenly, and often fatally, attacked in a way that jolts the audience.

How's it done?

It can be done as a practical effect or as CGI.

When should I use it?

Use this shot in moments when you want the audience to know how vulnerable the characters are to the creature. The more off-guard the character and the audience the better it will work.

DEEP BLUE SEA (1999)

Synopsis: Scientists Susan McCallister (Saffron Burrows) and Jim Whitlock (Stellan Skarsgård) are conducting research on regenerating brain tissue in sharks, hoping to find a cure for Alzheimer's disease. But when their funding is threatened, the pair decides to take a dangerous shortcut. Through DNA modification, they breed larger sharks with larger brains—and near-human intelligence. Soon, the sharks grow resentful of their captivity.

Featured Scene: In the airlock Russell (Samuel L. Jackson) gets snatched into the water by a massive shark.

Deep Blue Sea (1999), directed by Renny Harlin

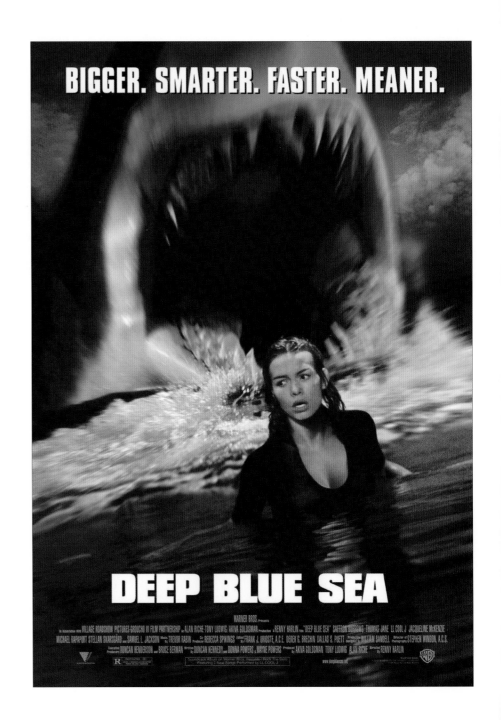

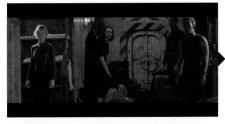 1

 2

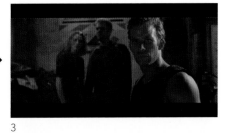 3

 4

 5

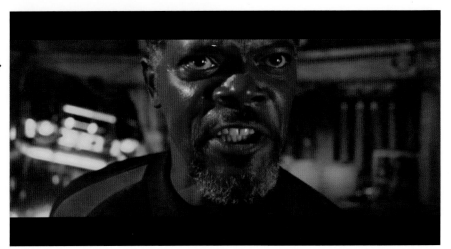 6

7

8

9

10

11

12

13

14

15

PIRANHA 3D (2010)

Synopsis: After a sudden underwater tremor sets free scores of the prehistoric man-eating fish, an unlikely group of strangers must band together to stop themselves from becoming fish food for the area's new razor-toothed residents.

Featured Scene: At the end of the film when all seems safe Novak (Adam Scott) is grabbed by a massive piranha.

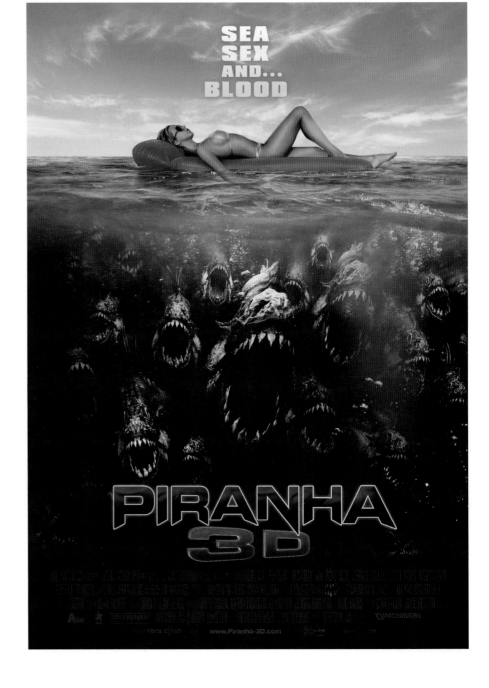

Piranha 3D (2010), directed by Alexandre Aja

1

2

3

4

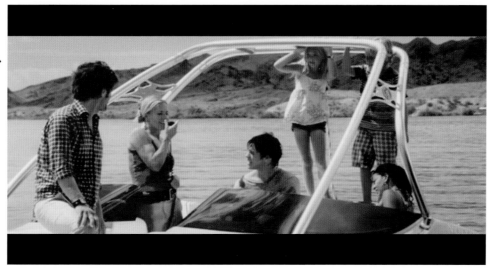

5

6

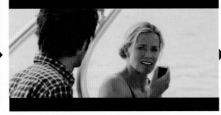

7

8

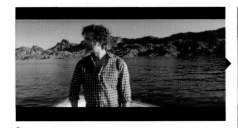

9

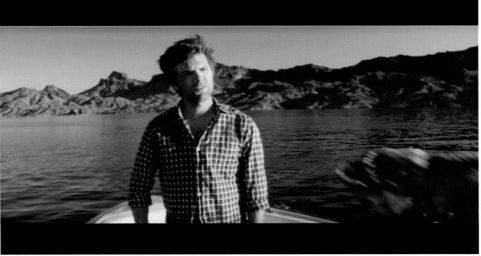

10

11

12

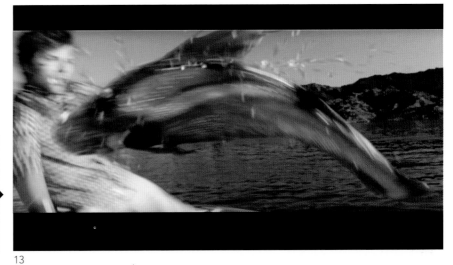
13

14

15

Face Off

What does it look like?

It's any shot where the main character and the creature "face off" in a prolonged moment of suspense.

How's it done?

This shot is usually framed in a two-shot and the creature is usually at a higher eye line than the human to show scale.

When should I use it?

Use this shot when you want to prolong the moment when a character meets a creature head on and is faced with a life and death decision to act.

ALIENS (1986)

Synopsis: In this acclaimed sequel, the only survivor from the first film, Lt. Ripley (Sigourney Weaver), finds her horrific account of her crew's fate is met with skepticism—until the disappearance of colonists on LV-426 prompts a team of high-tech Marines to investigate. Ripley travels with the team as an advisor, only to find that her biggest fear has come true.

Featured Scene: The scene in the nest of the aliens when Ripley saves Newt.

Aliens (1986), directed by James Cameron

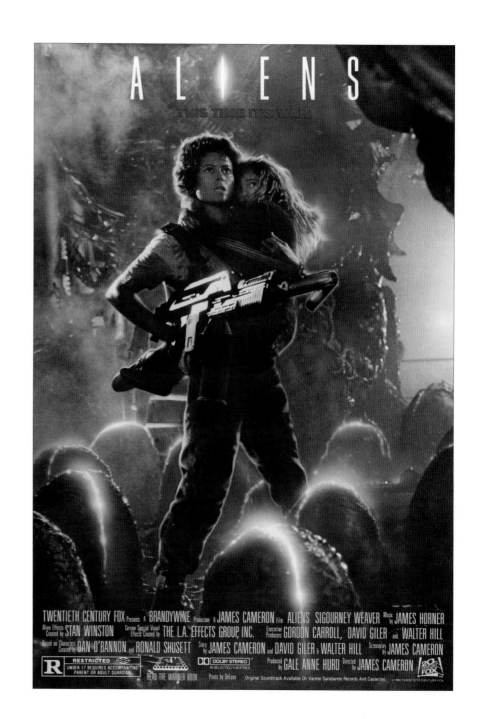

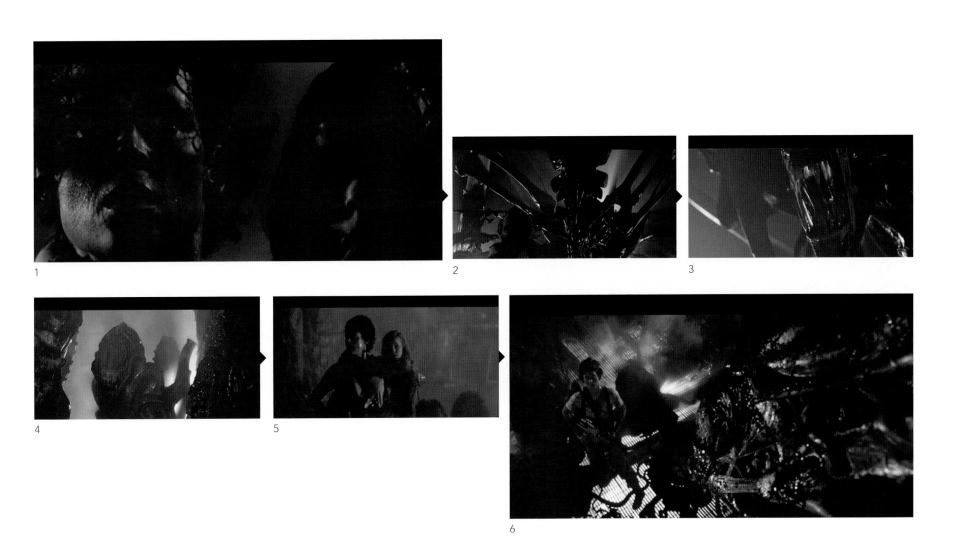

1

2

3

4

5

6

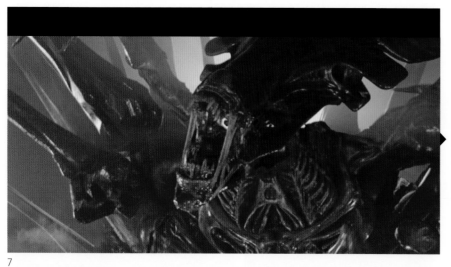

7

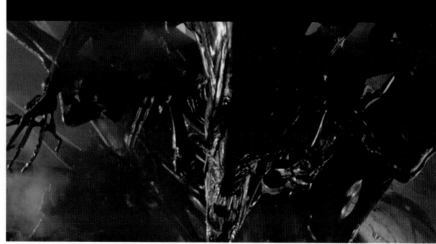

8

9

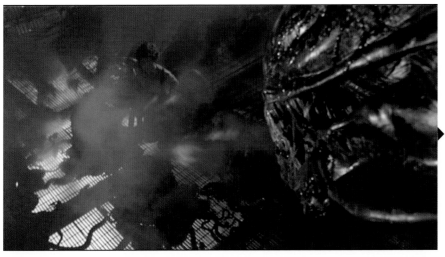

10

11

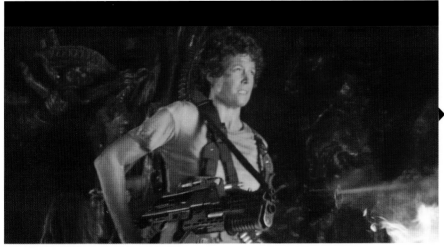

12

13

DREAMCATCHER (2003)

Synopsis: Four boyhood pals perform a heroic act and are changed by the powers they gain in return. Years later, on a hunting trip in the Maine woods, they're overtaken by a vicious blizzard that harbors an ominous presence. Challenged to stop an alien force, the friends must first prevent the slaughter of innocent civilians by a military vigilante ... and then overcome a threat to the bond that unites the four of them.

Featured Scene: The scene in the cabin after the alien kills Beaver.

Dreamcatcher (2003), directed by Lawrence Kasdan

1

2

3

4

5

6

7

8

9

10

11

12

13

14

15

16

17

18

Man vs. Alien

What does it look like?

It's any shot that shows a human being in a way that dwarfs him compared to the alien threat he is confronted with in a scene. It could be a fleet of invading spacecraft (using landmarks for scale) or a direct confrontation with a character.

How's it done?

It's usually a series of shots starting with a wide, then progressing to a high angle looking down on the human, then a low angle looking up at the alien threat.

When should I use it?

Use this shot to sell the threat and to show the scale of the action.

INDEPENDENCE DAY (1996)

Synopsis: When aliens in enormous spacecraft suddenly arrive in Earth's atmosphere and start blowing things up, it falls to a cocky pilot (Will Smith) and a goofy scientist (Jeff Goldblum) to save the planet from total destruction.

Featured Scene: The scene when the alien spaceships hover over the city.

Independence Day (1996), directed by Roland Emmerich

1

2

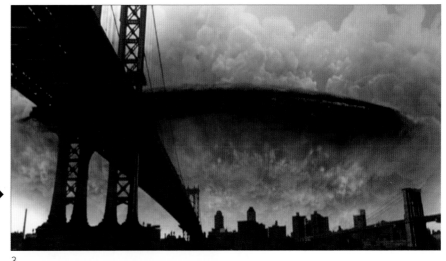

3

4

5

6

7

8

9

10

11

12

13

WAR OF THE WORLDS (2005)

Synopsis: In this loose adaptation of H.G. Wells's novel about alien invasion, Tom Cruise stars as Ray, a divorced dockworker whose children (Dakota Fanning and Justin Chatwin) are staying with him for the weekend when a fleet of spaceships carrying tripod creatures appears in his neighborhood.

Featured Scene: The scene when Ray is attacked in the truck outside of the cabin.

War of the Worlds (2005), directed by Steven Spielberg

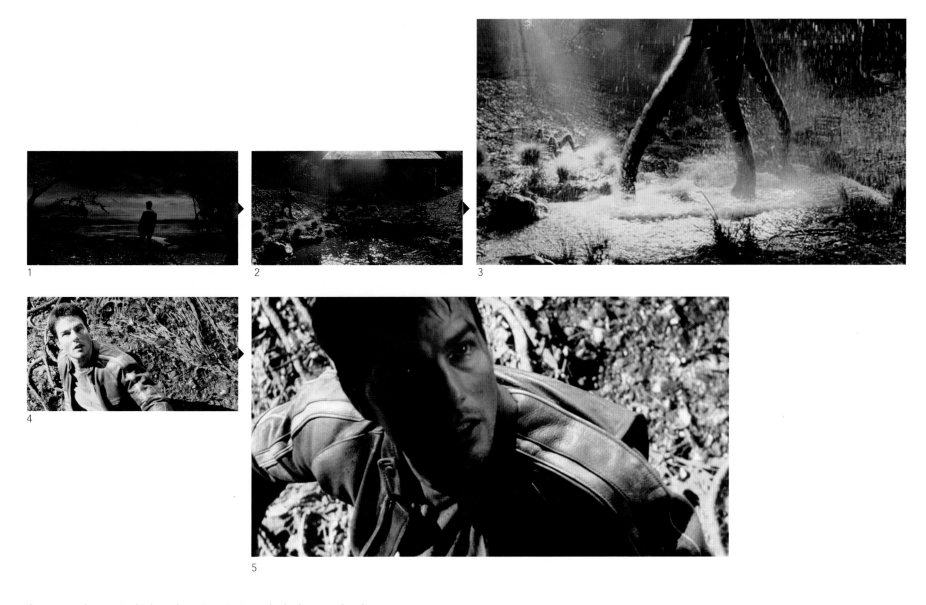

The camera does a nice high angle on Tom Cruise as he looks up at the alien
then swoops and tilts to a low angle looking up at the alien.

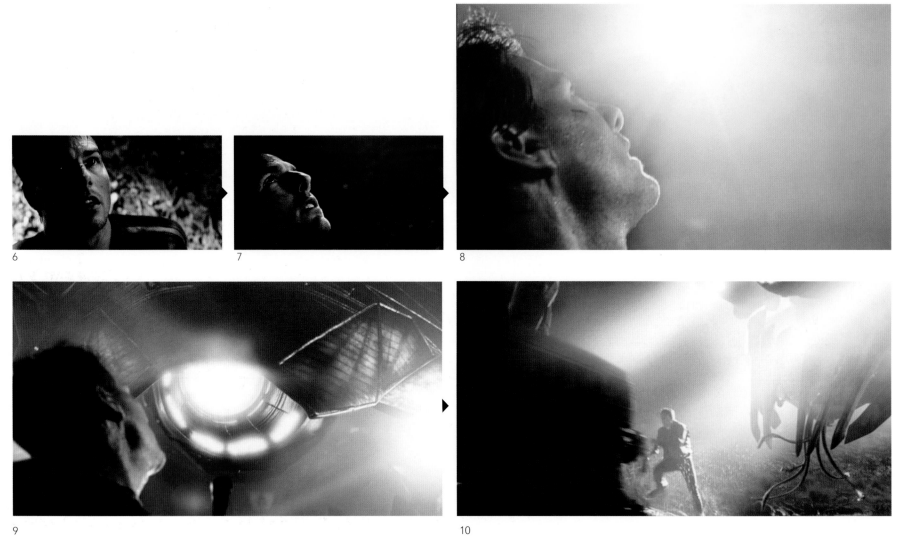

6

7

8

9

10

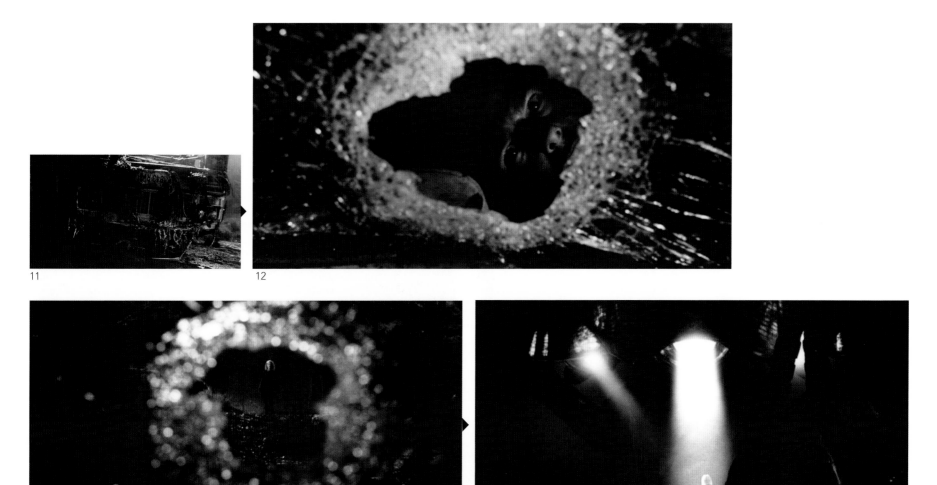

11

12

13

14

Man vs. Nature

What does it look like?

It's any shot that shows a human being in a way that dwarfs him compared to a natural disaster or apocalyptic event.

How's it done?

These shots are always done as CGI and on a grand scale to sell it.

When should I use it?

It's best to use this shot as much as possible in a disaster sequence to show the massive scale of what is happening. The more the humans are dwarfed compared to what is approaching them the better.

DEEP IMPACT (1998)

Synopsis: A 7-mile-wide space rock is hurtling toward Earth, threatening to obliterate the planet. To save the world, the U.S. president appoints a steely veteran astronaut to lead a joint American-Russian crew into space to destroy the comet before impact.

Featured Scene: The scene where the asteroid hits the ocean and creates a massive tsunami.

Deep Impact (1998), directed by Mimi Leder

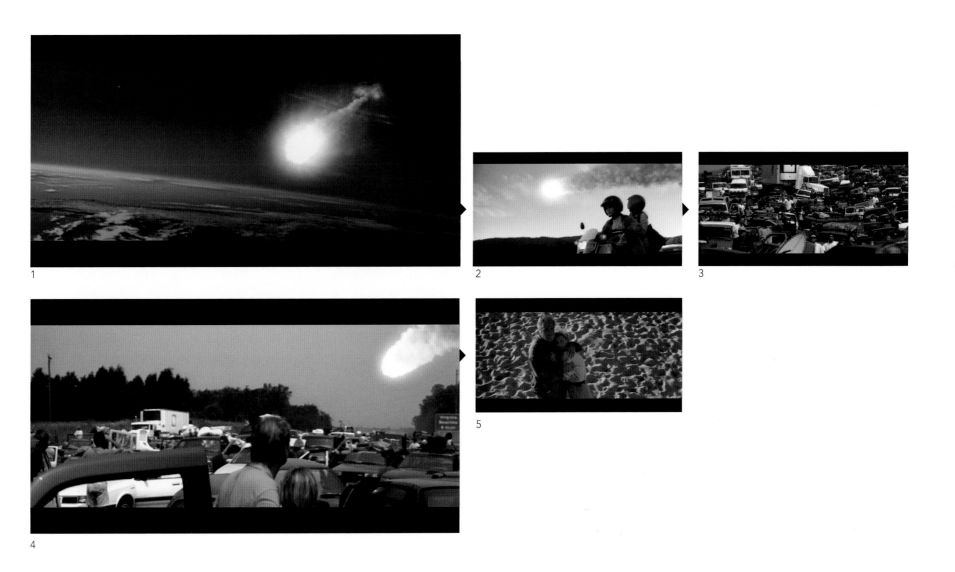

1

2

3

5

4

In this sequence you will see many wide shots to sell the man vs. nature motif.

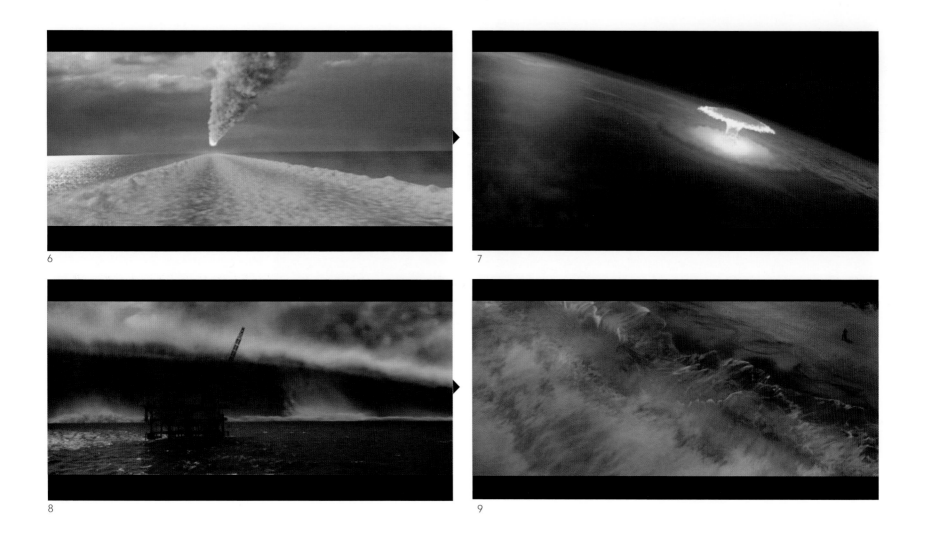

6

7

8

9

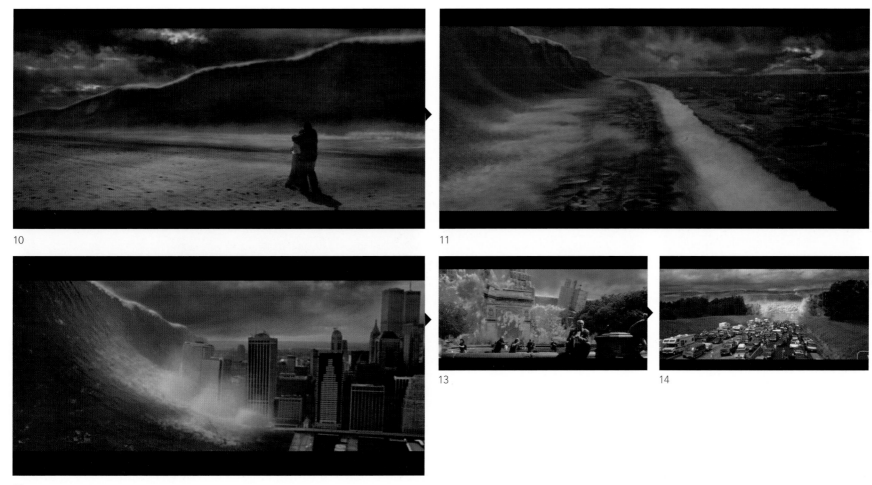

10

11

12

13

14

Bullet Time

What does it look like? It's a shot that takes normal time and slows it down to show what would normally be unfilmable or imperceptible events, such as bullets flying through the air.

How's it done? This shot is CGI.

When should I use it? Use this shot when you want to draw attention to objects or events that would normally be imperceptible to an audience. It can prolong a moment for emphasis or just for stylized filmmaking.

THE MATRIX (1999)

Synopsis: In this complex story that aspires to mythology, a computer hacker (Keanu Reeves) searches for the truth behind the mysterious force known as the Matrix. He finds his answer with a group of strangers led by the charismatic Morpheus (Laurence Fishburne).

Featured Scene: The scene on the rooftop when an agent shoots at Neo.

The Matrix (1999), directed by Andy and Larry Wachowski

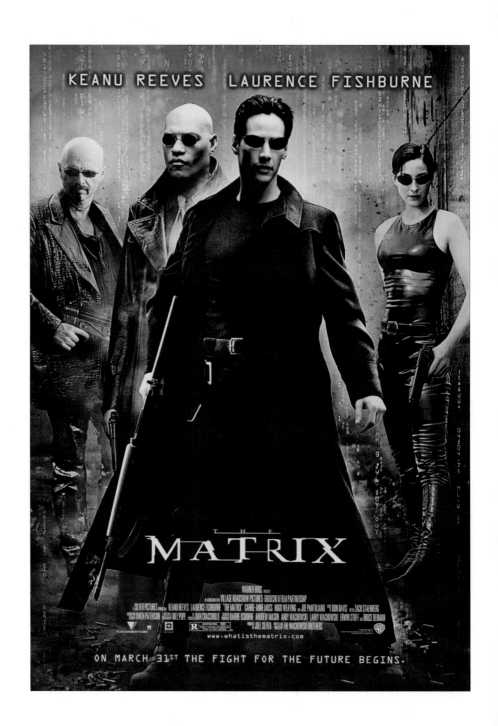

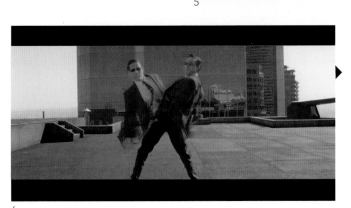

1

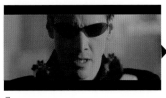

2

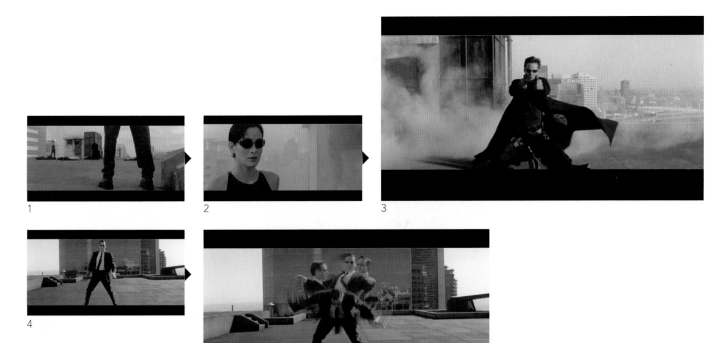

3

4

5

6

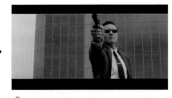

7

8

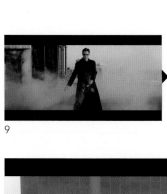

9

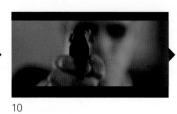

10

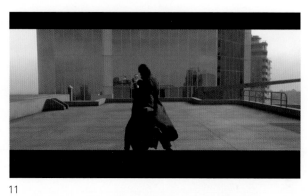

11

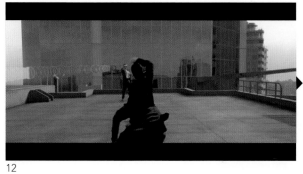

12

13

14

15

16

The camera does a 360 spin around Neo in "Bullet Time".
The first film to use this technique.

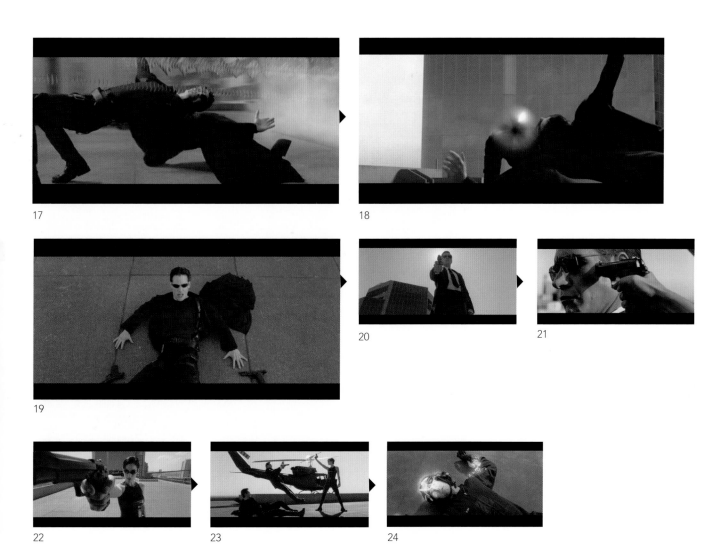

17

18

19

20

21

22

23

24

The Abduction Shot

What does it look like?
It's a shot that is characterized by a strong beam of light coming from an alien object that seemingly takes control of the character's facilities.

How's it done?
It's done on set with a very powerful light.

When should I use it?
Use this shot to show a character who is overtaken by an alien force. The more direct and "heavenly" the beam of light, the better.

FIRE IN THE SKY (1993)

Synopsis: While driving through the countryside with his friends, Travis Walton is struck by a bolt of energy beaming from the sky and then disappears for days. When he returns, he claims he was abducted by aliens and spent the week on their ship.

Featured Scene: The scene when the boys follow a red light in the forest and find a hovering spacecraft that one of them decides to stand under.

Fire in the Sky (1993), directed by Robert Lieberman

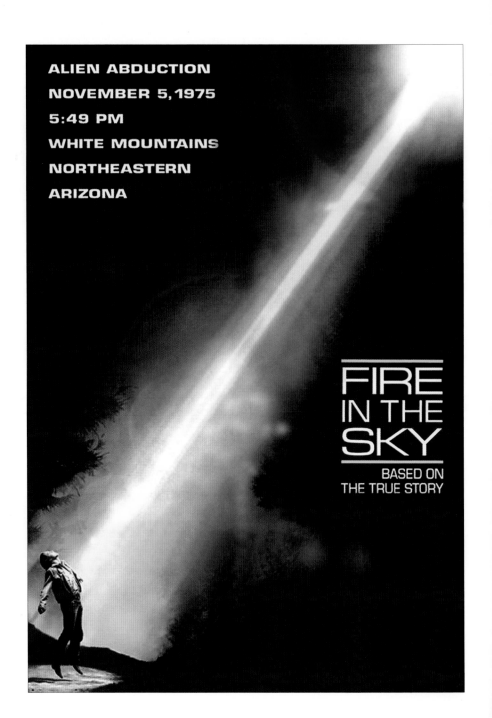

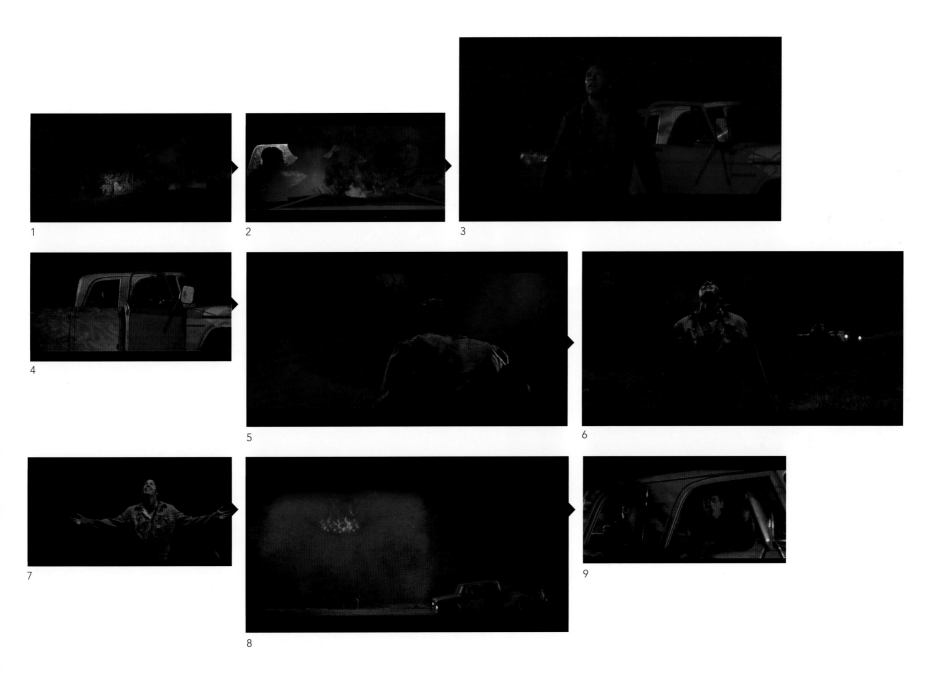

1

2

3

4

5

6

7

8

9

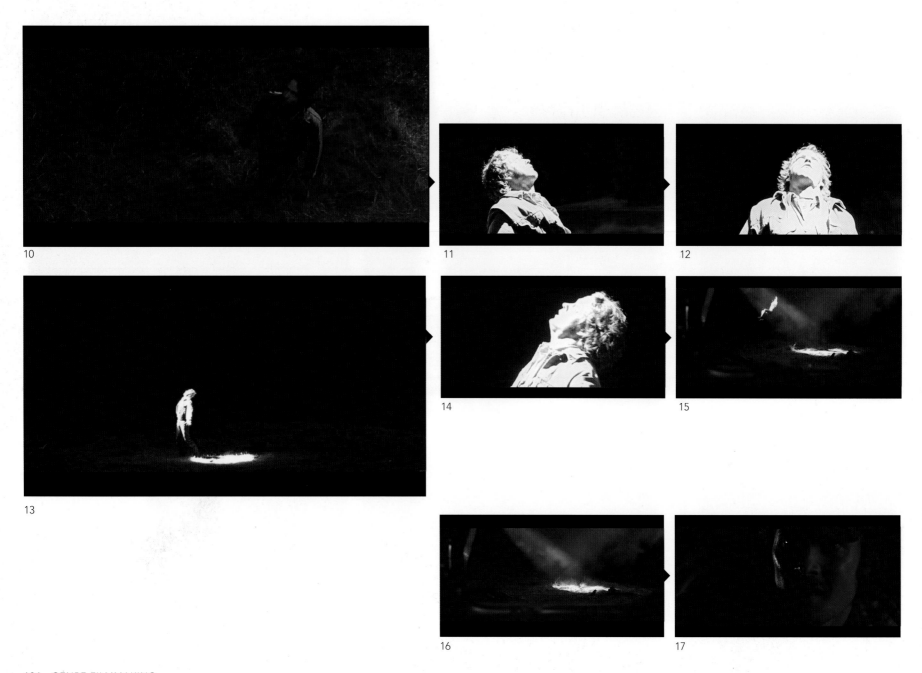

10 11 12

13 14 15

16 17

The Creature Inside

What does it look like?

It's a shot that starts wide and pushes into and down the throat of a screaming individual to reveal something hideous hiding inside.

How's it done?

This shot is a combination of live action and CGI to form one continuous shot.

When should I use it?

Use this shot as a stylized way to reveal something inside the human body that is alien.

ALIEN RESURRECTION (1997)

Synopsis: Sigourney Weaver and Winona Ryder star in the fourth installment of the Alien series. Two hundred years after Lt. Ripley (Weaver) died, a group of scientists clone her, hoping to breed the ultimate weapon. But the new Ripley is full of surprises … as are the new aliens. Ripley must team with a band of smugglers (including Ryder) to keep the creatures from reaching Earth.

Featured Scene: The scene in when the alien breaks out of the man's chest and through another man's head.

Alien Resurrection (1997), directed by Jean-Pierre Jeunet

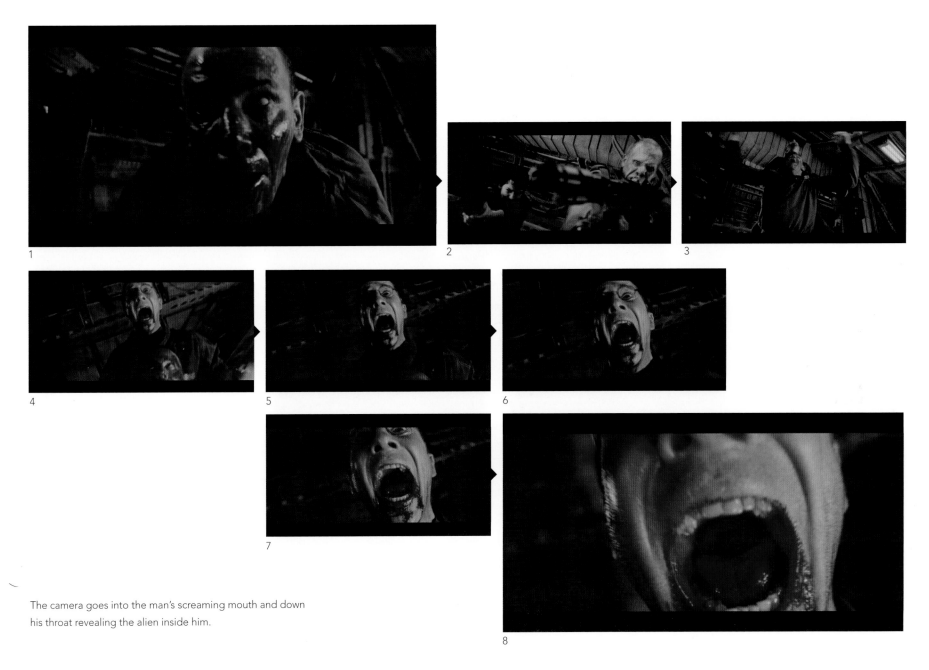

The camera goes into the man's screaming mouth and down his throat revealing the alien inside him.

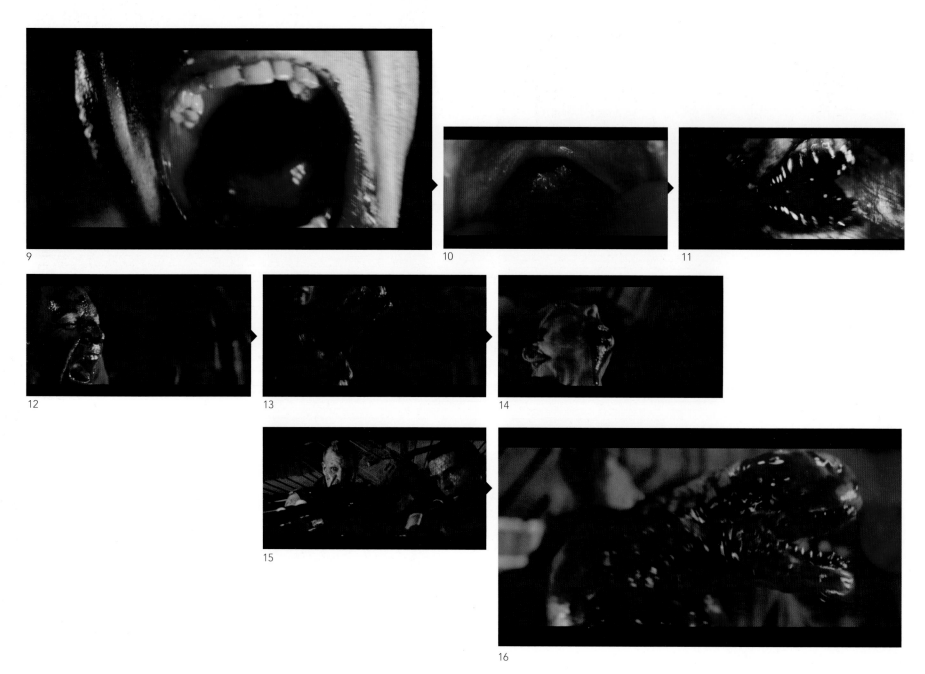

9

10

11

12

13

14

15

16

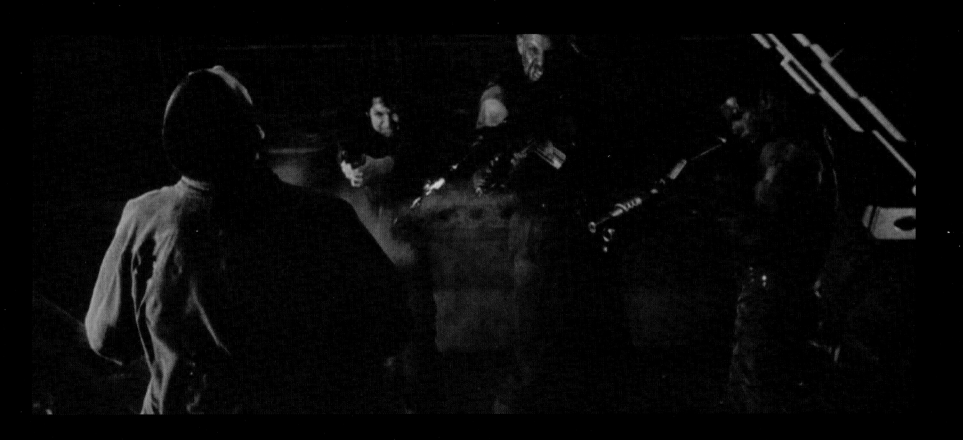

The Eye Reflection

What does it look like?

It's any shot that uses the surface of the eye to reflect what it is seeing for dramatic effect.

How's it done?

These shots are always done as CGI.

When should I use it?

Use this shot in moments when you want to draw attention to the events being seen by the observer.

BLADE RUNNER (1982)

Synopsis: In a smog-choked dystopian Los Angeles, blade runner Rick Deckard (Harrison Ford) is called out of retirement to kill a quartet of escaped "replicants"—androids consigned to slave labor on remote planets—seeking to extend their short life spans.

Featured Scene: The scene in the opening of the film that reflects the cityscape in a man's eyeball.

Blade Runner (1982), directed by Ridley Scott

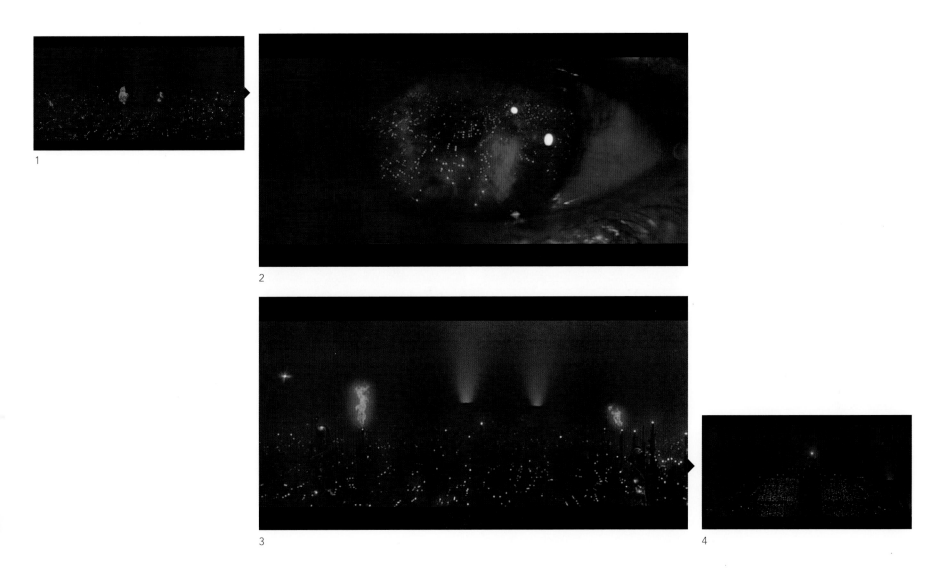

1

2

3

4

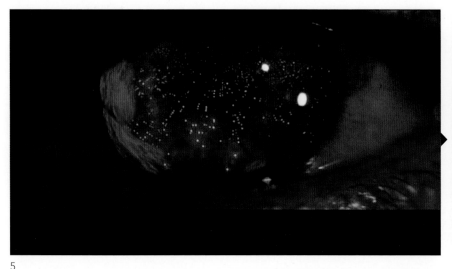

5

6

7

8

9

10

11

SECTION FOUR

The Thriller Genre

Thriller | one that thrills; especially a work of fiction or drama designed to hold the interest by the use of a high degree of intrigue, adventure, or suspense.

The Eavesdropper Shot

What does it look like?

The shot starts wide showing a conversation in the background and a character in the foreground listening. The shot then slowly pushes into a tighter shot and becomes more intimate as the character and the audience listen.

How's it done?

It's accomplished by using a dolly or Steadicam to push into a tighter shot.

When should I use it?

Use this shot when you want the audience to listen to the conversation alongside the character. It's particularly good when story information is being divulged.

CHILDREN OF MEN (2006)

Synopsis: This film is set in a futuristic world in which humans have lost the ability to reproduce and subsequently face certain extinction. Things change when a single woman mysteriously becomes pregnant, prompting a conflicted government bureaucrat (Clive Owen) and his ex-wife (Julianne Moore) to join forces to protect her.

Featured Scene: At the cabin, Theo eavesdrops on a conversation in the living room.

Children of Men (2006), directed by Alfonso Cuaron

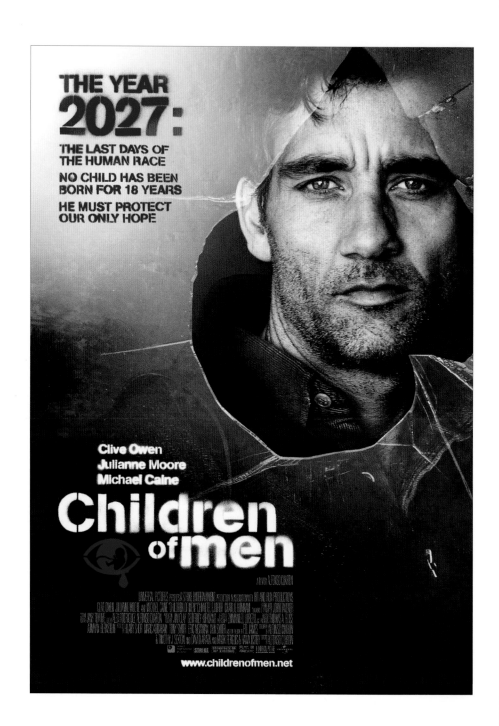

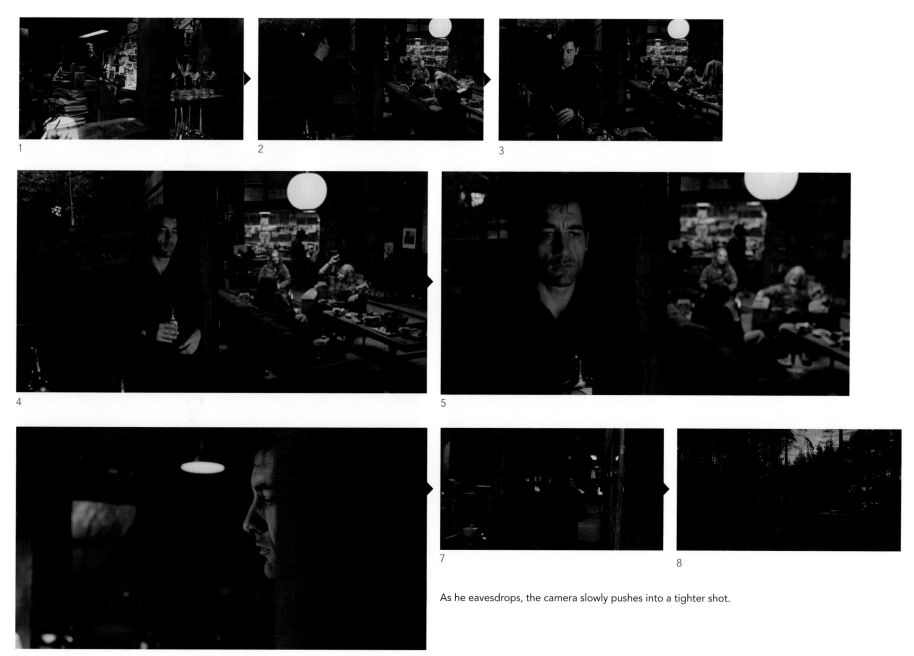

As he eavesdrops, the camera slowly pushes into a tighter shot.

The Unexpected Jump

What does it look like?

It's unexpected "jump" moment or cut where the character almost gets seriously injured or killed.

How's it done?

It's done as a practical shot on the set.

When should I use it?

It's best used during moments in the film where the character is off guard and vulnerable to an attack.

COLOR OF NIGHT (1994)

Synopsis: Bruce Willis stars as a troubled psychiatrist who quits after a patient commits suicide. But when a colleague is murdered, he gets drawn into a web of intrigue—and into the arms of a patient who's also a suspect.

Featured Scene: Bill (Bruce Willis) returns from a jog then opens his mailbox and dodges a rattlesnake.

Color of Night (1994), directed by Richard Rush

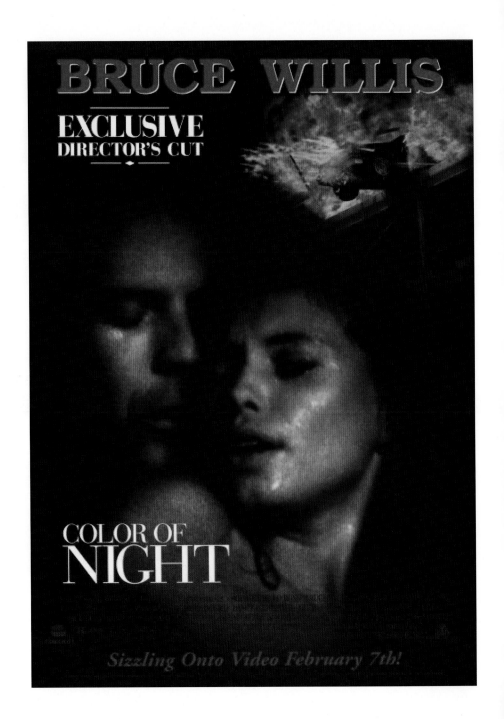

1

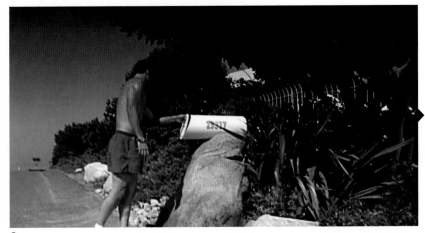

2

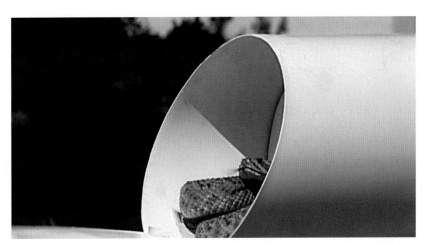

3

4

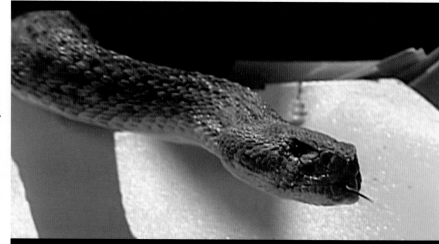

5

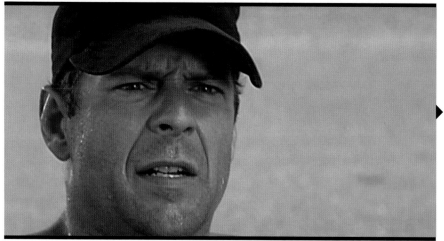

6

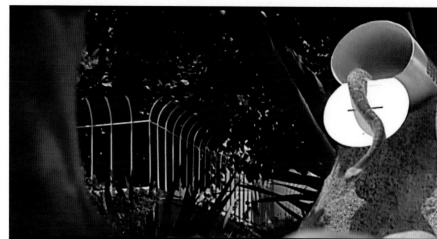

7

8

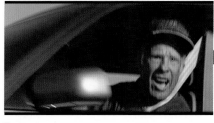

9

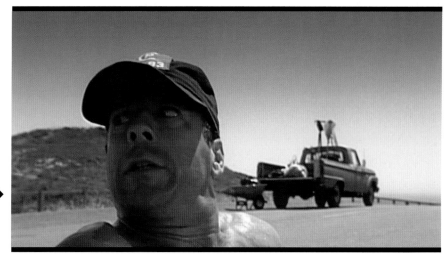

10

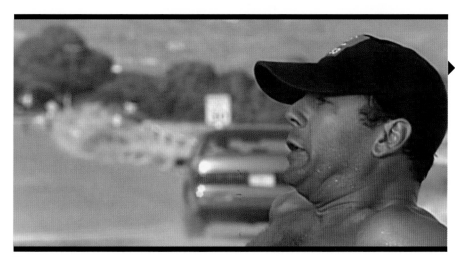

11

12

The Car Pursuit

What does it look like?
It's any shot that uses a car's mirror to show the reflection of a vehicle pursuing a character. It's usually in a side or rear view mirror. This shot is from the perspective of the character being pursued and usually only inside the car.

How's it done?
It's accomplished by shooting the reflection inside a moving vehicle. It's also nice to include the eyes of the character in the mirror as well.

When should I use it?
Use this shot to build suspense and to show the action of the car behind.

DUEL (1971)

Synopsis: A business commuter is pursued and terrorized by a malevolent driver of a massive tractor-trailer.

Featured Scene: On the open road, David (Dennis Weaver) is pursued by a faceless madman in a semi truck.

Duel (1971), directed by Steven Spielberg

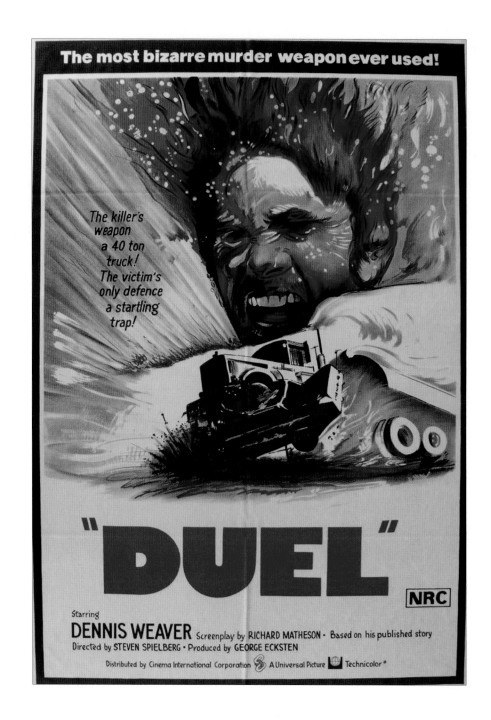

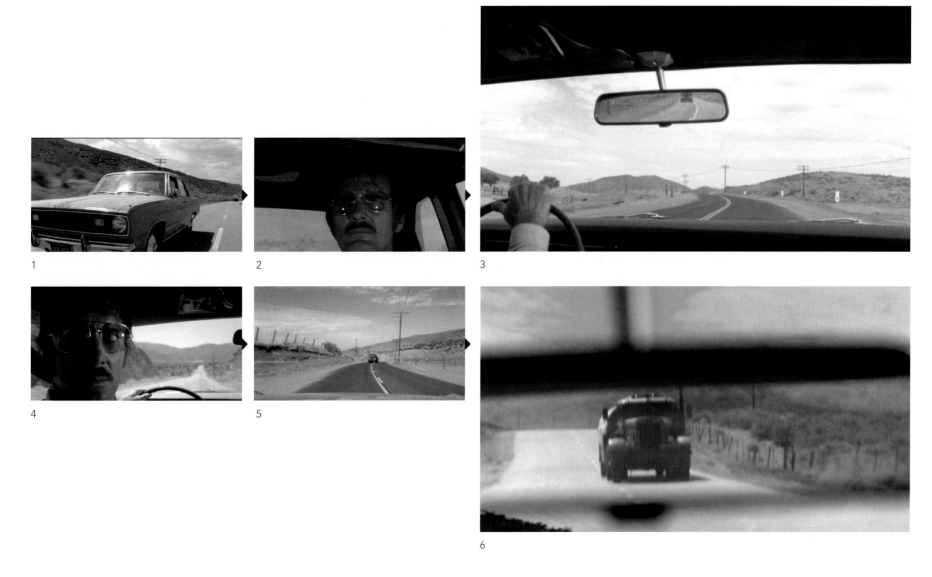

1
2
3
4
5
6

The reflection shot appears many times during this sequence.

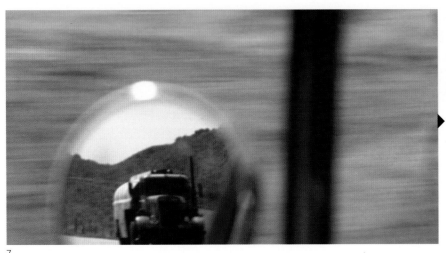

7

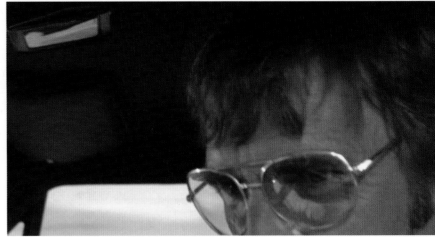

8

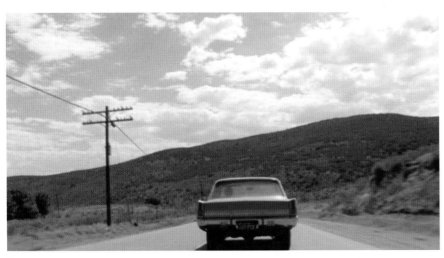

9

10

11

12

13

Back from the Dead

What does it look like?

It's any unexpected moment when a character is presumed dead but jumps back to life for one last attack.

How's it done?

It's shot and framed in a way that sets up the attack for maximum surprise. The "back from the dead" moment is usually from an area in the frame where the character is most off-guard, such as from behind.

When should I use it?

Use this shot to thrill the audience one last time before killing off the villain. It shows how hard he/she is to kill and also heightens the fear level for the audience.

FATAL ATTRACTION (1987)

Synopsis: Married attorney Dan Gallagher gives in to the tantalizing flirtations of attractive editor Alex Forrest, and they embark on a steamy affair. But Dan's passing indiscretion comes back to haunt him as an increasingly unhinged Alex refuses to let go.

Featured Scene: In the bathroom scene at the end of the film when Alex (Glen Close) is presumed dead, she jumps back to life for one last attack.

Fatal Attraction (1987), directed by Adrian Lyne

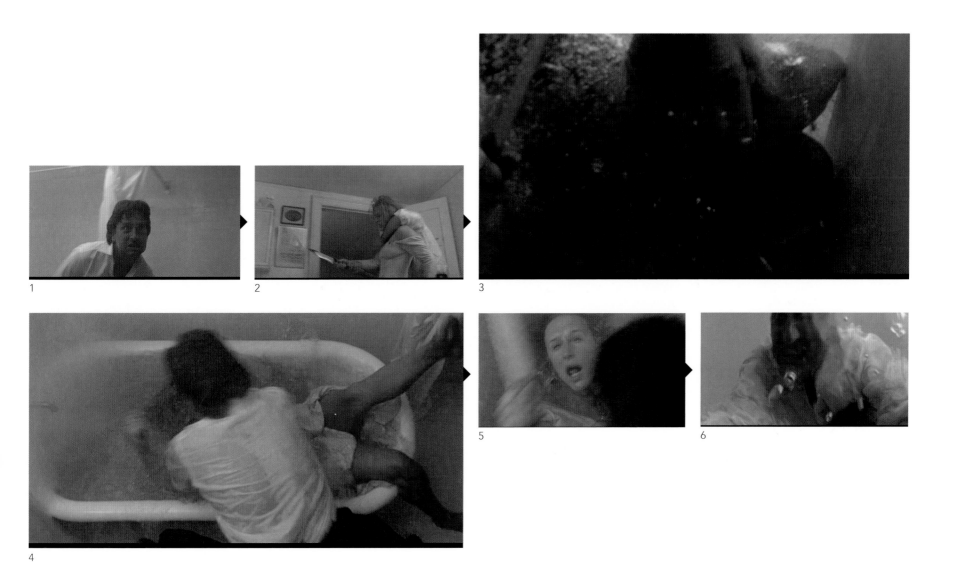

1

2

3

4

5

6

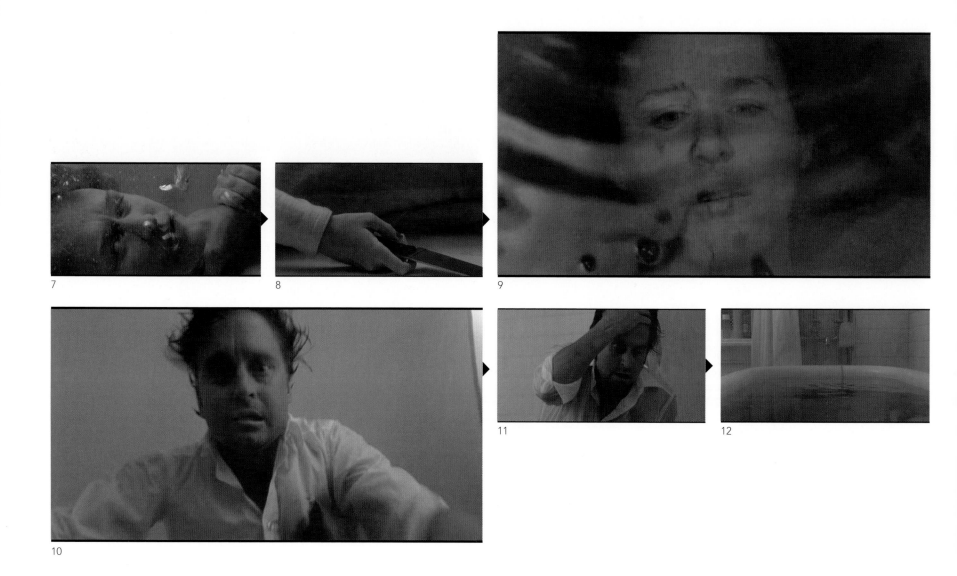

7

8

9

10

11

12

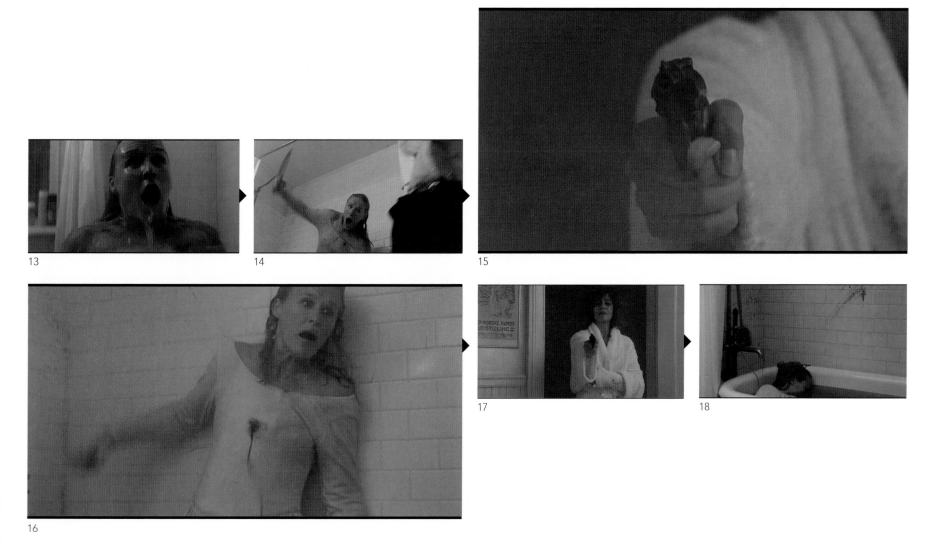

13 14 15

16 17 18

Under Surveillance

What does it look like?
It's a camera viewfinder POV shot that follows a subject in order to take a photo. Once a photo is taken, a still frame shot is created revealing the picture taken to the audience.

How's it done?
It's done in post-production by creating a still frame and/or cutting in a photo for artistic effect.

When should I use it?
Use this shot to show a scene or person of interest that is being investigated or spied on.

ENEMY OF THE STATE (1998)

Synopsis: Hotshot lawyer Robert Dean becomes a victim of high-tech identity theft when a hacker slips an incriminating video into his pocket. Soon, a rogue National Security agent sets out to recover the tape—and destroy Dean.

Featured Scene: Outside of a mob establishment, Robert discovers he is being photographed by the FBI.

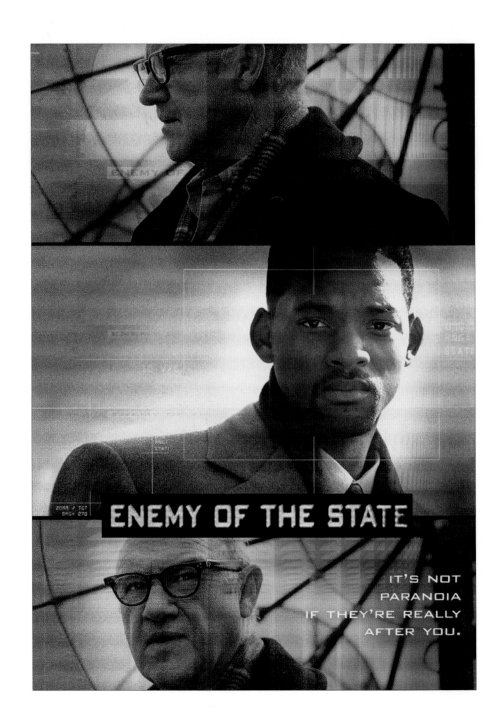

Enemy Of The State (1998), directed by Tony Scott

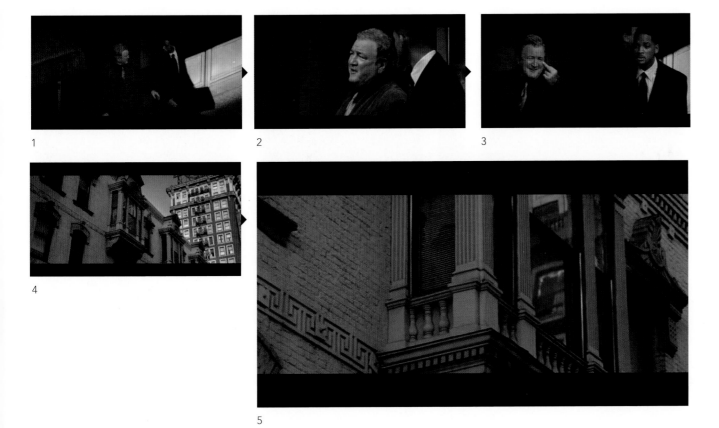

1

2

3

4

5

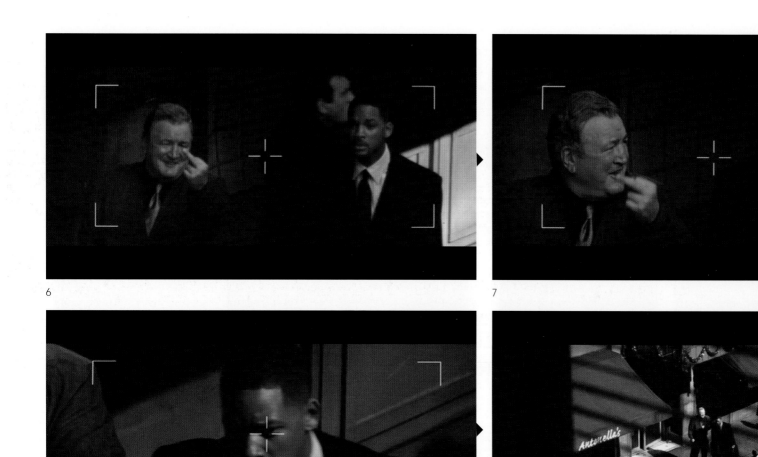

6

7

8

9

10

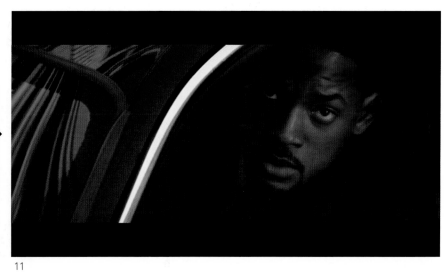

11

The Urgent Call

What does it look like?

It's a shot that reveals a character's reaction in a quick way by using a rack focus from the phone to the character's face, or vice versa.

How's it done?

It's done by starting or ending on a shot of a phone and using a rack focus of the lens to go from the phone to the character. It could also be in a reflection on the phone display screen, mirror, or tabletop.

When should I use it?

This shot is best used for phone calls that could mean life or death for the characters. It's a great way to combine an ordinary shot of a phone with an emotional reaction of a character and draw attention to the importance of the call.

PRISON BREAK – SEASON 4 (2008)

Synopsis: Brothers Lincoln and Michael are on the loose again after breaking out of a dangerous Panamanian prison, but the shadowy agents who framed Lincoln for murder are on their trail. Unlike their last breakout, this time the brothers are seeking revenge.

Featured Scene: The General almost shoots Teabag, but he is saved by an urgent call.

Prison Break (2008), Season 4

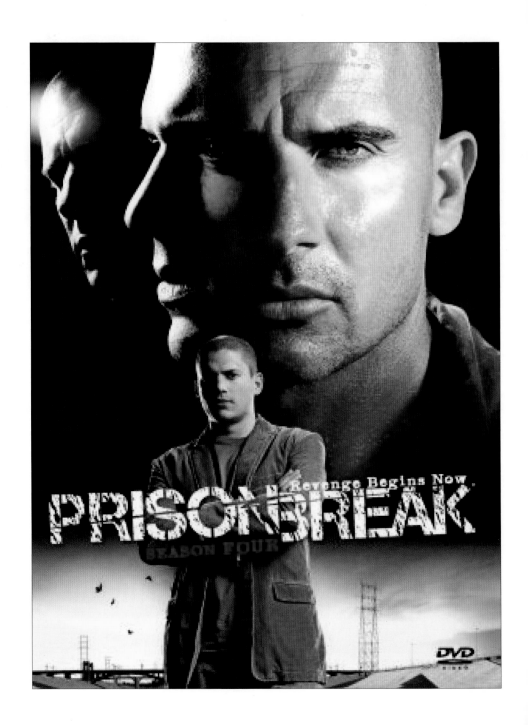

The shot racks from the phone to a reflection on Teabag's face, then tilts up to continue the action.

6

7

8

9

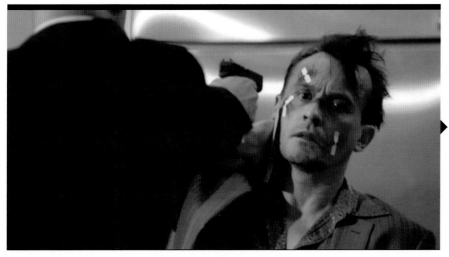

10

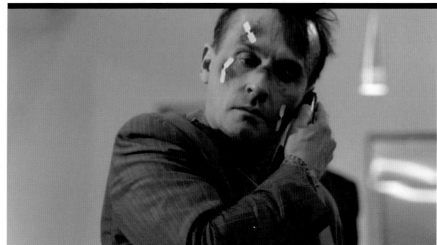

11

Panic 360 Shot

What does it look like?

It's a shot that spins wildly around a character and blurs out all other action.

How's it done?

It's achieved by using a dolly or a Steadicam that moves in one consistent direction at a quick pace.

When should I use it?

Use this shot during moments when the world is turned upside down for your characters and they don't know what to do. It's perfect for moments of confusion, paranoia and panic.

SHATTERED (2007)

Synopsis: A Chicago couple's perfect life is instantly turned upside down when a kidnapper with an elaborate scheme abducts their little girl. With the clock ticking down on their daughter's life, they're forced to comply with the orders of a madman.

Featured Scene: When the couple walks out of a restaurant and start to panic.

Shattered (2007), directed by Mike Barker

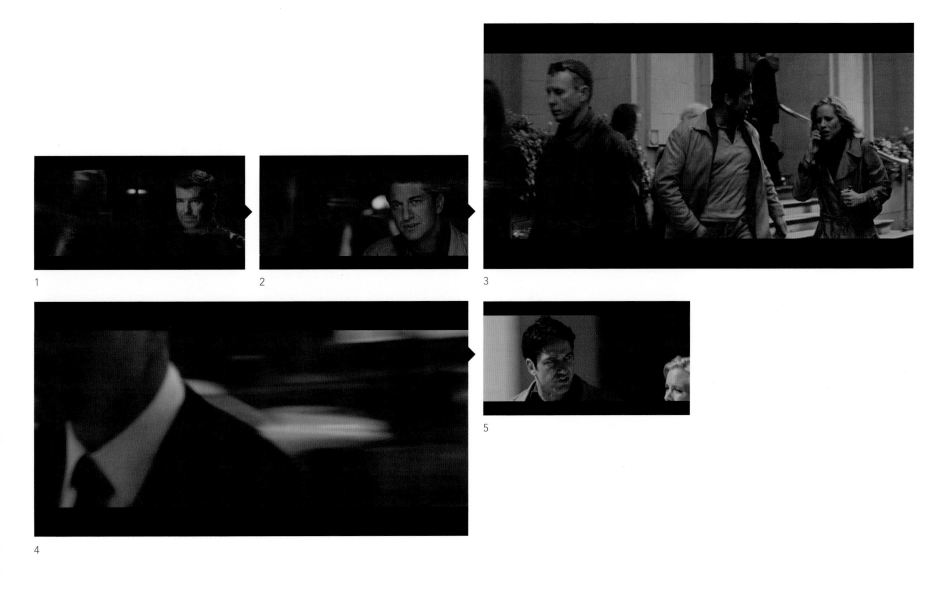

The camera spins to the left in one direction only.

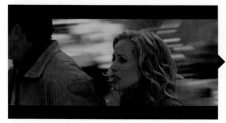

6

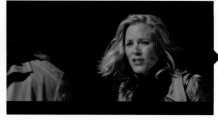

7

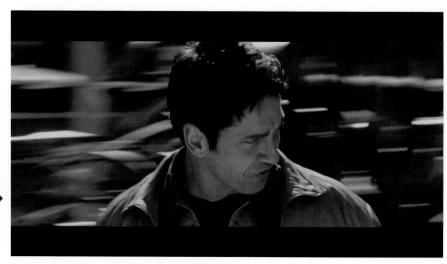

8

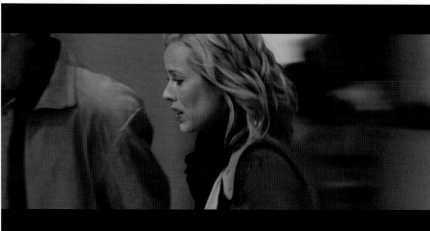

9

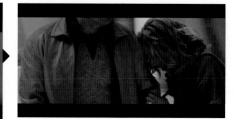

10

11

12

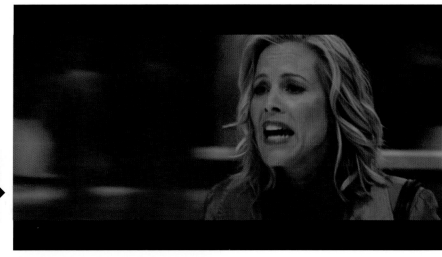

13

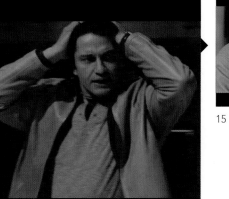

14

15

Almost Captured

What does it look like?

It's a sequence of shots that brings a main character in close proximity to capturing the villain. The shot of the villain is from a distance in order to conceal his/her identity.

How's it done?

It can be shot and edited in a variety of ways, but the key is not to reveal the identity of the villain by keeping those shots wide.

When should I use it?

Use this shot to build tension and suspense. It's great to make the audience feel as if "they almost got him".

S E V E N (1995)

Synopsis: Two homicide detectives are on a desperate hunt for a serial killer (Kevin Spacey) whose crimes are based on the "seven deadly sins". The seasoned Det. Sommerset (Morgan Freeman) researches each sin in an effort to get inside the killer's mind, while his novice partner, Mills (Brad Pitt), scoffs at his efforts to unravel the case.

Featured Scene: The detectives investigate an apartment building and almost catch the killer in the hallway.

Seven (1995), directed by David Fincher

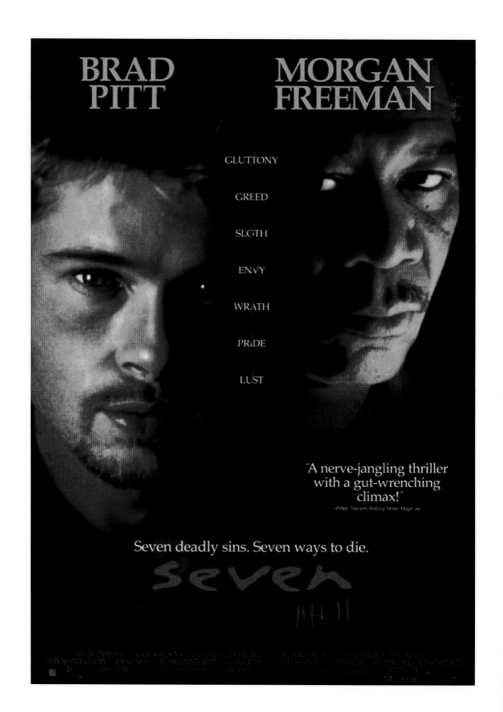

1

2

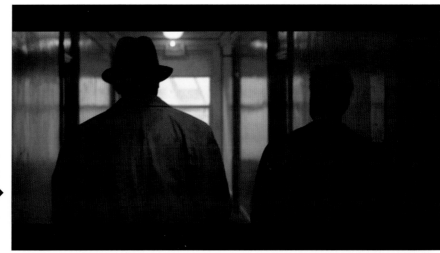

3

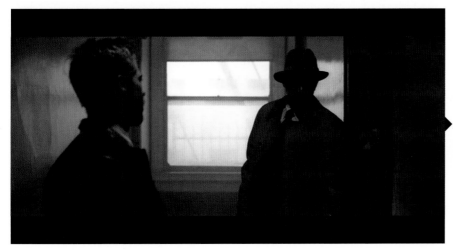

4

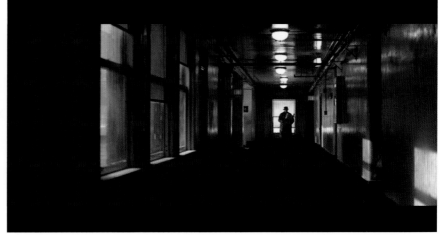

5

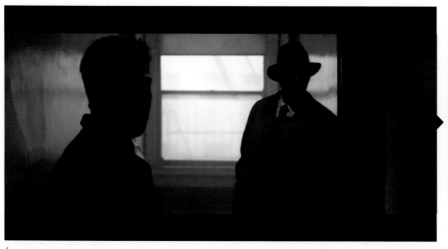

6

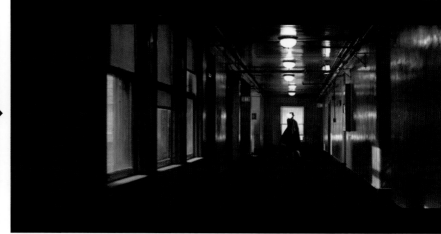

7

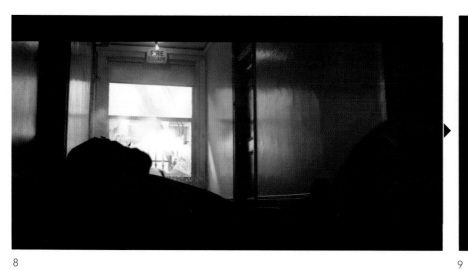

8

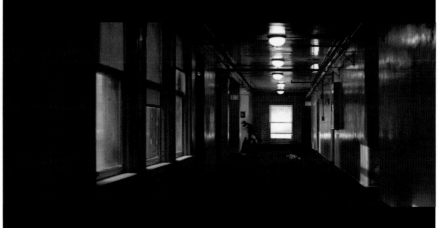

9

10

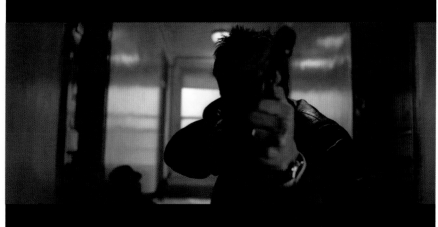

11

12

Hiding from Danger (Split Focus)

What does it look like?

It's any shot where there is action in the foreground and the background and both parts of the frame are split and in focus.

How's it done?

It's done by using a split-focus diopter on the lens.

When should I use it?

Use this shot during a pursuit to build suspense. It's a great way to combine the action and capture the fear on the person's face in the foreground.

JUDGMENT NIGHT (1993)

Synopsis: A seemingly innocent night out turns deadly when four friends (Emilio Estevez, Cuba Gooding Jr., Jeremy Piven and Stephen Dorff) run over a man with their car while detouring through the neighborhood. They try to do the right thing and find a cop, but a merciless thug named Fallon (Denis Leary) is determined to stop them. Fallon had a beef with the injured man, so he finishes off the job—and promises the guys that they're next.

Featured Scene: During the sewer pursuit the men try to hide.

Judgment Night (1993), directed by Stephen Hopkins

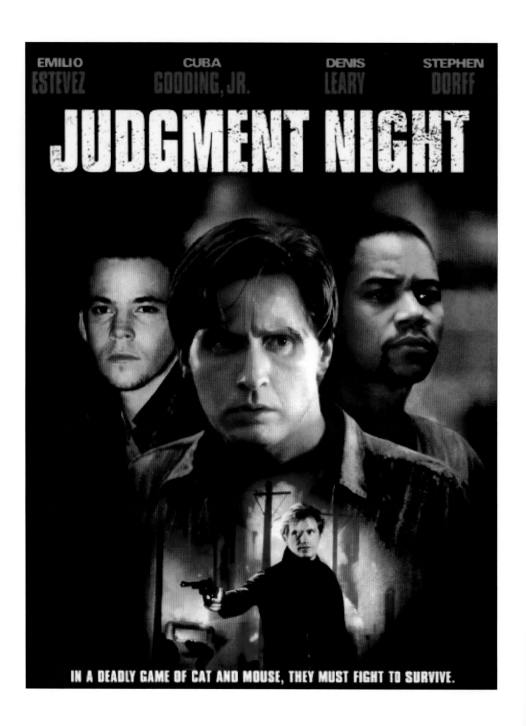

1

2

3

4

5

6

7

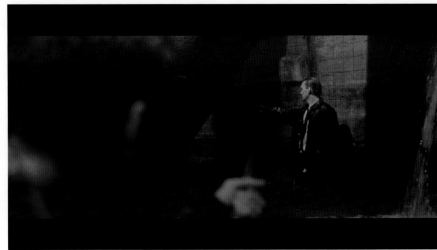

8

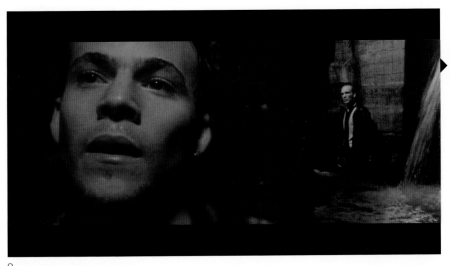

9

10

11

Danger in a Reflection

What does it look like?

It's a shot where a character is hiding behind a wall and through a reflection we can see a bad guy approaching.

How's it done?

It's done by shooting the reverse action in the reflection.

When should I use it?

Use this shot to show the audience and/or the character the danger that is on the other side of the wall.

PAYCHECK (2003)

Synopsis: Paid big money by high-tech firms for working on hush-hush projects, computer ace Michael Jennings then has his memory erased for security purposes—which explains why he can't figure out the reason his most recent employer wants to kill him.

Featured Scene: During a pursuit in the basement, Jennings tries to escape with his life.

Paycheck (2003), directed by John Woo

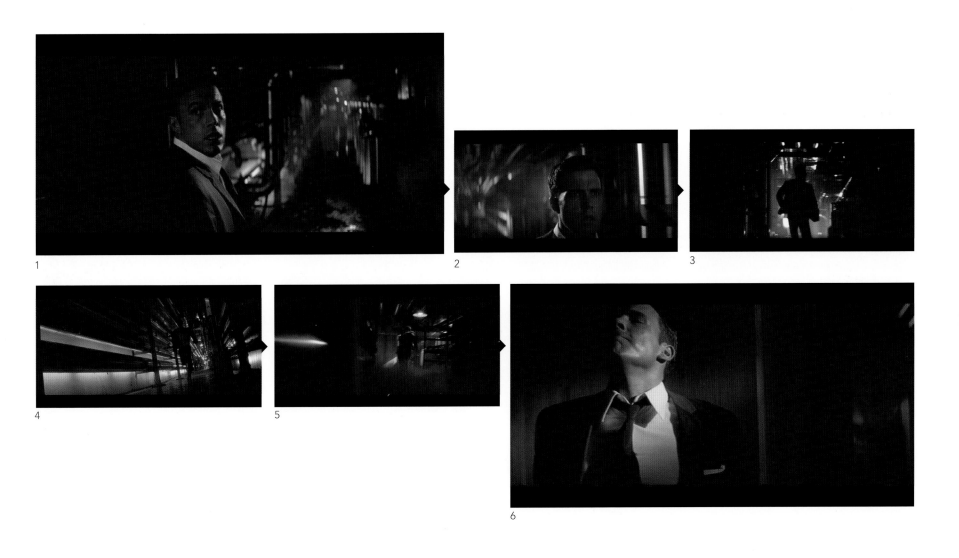

This shot follows the character looking around the corner, does a rack focus revealing the reflection, then follows his head movement back to where he started.

7

8

9

10

11

Cigarette Time Passage Transition

What does it look like?

This transition is two shots: the first sets up the scene while the second shows a cigarette that has burned down to the filter. This visual cue is enough for an audience to know that time has passed and they're now ready to continue the scene.

How's it done?

The transition is just a simple straight cut done in post-production.

When should I use it?

Use this shot to let the audience know that the characters have been talking for a long period of time. It's a great way to show a character explaining himself or his problems but without the exposition.

UNKNOWN (2011)

Synopsis: Liam Neeson stars as a man who regains consciousness after an auto accident only to discover that another man is impersonating him, and that no one—not even his wife (January Jones)—recognizes his identity as the real Dr. Martin Harris. Finding himself with an unexpected ally (Diane Kruger), Harris struggles to solve the mystery and hang onto his own wits, while also being stalked by anonymous killers.

Featured Scene: The scene where Dr. Martin Harris (Liam Neeson) is talking with an old spy (Bruno Ganz).

Unknown (2011), directed by Jaume Collet-Serra

1

2

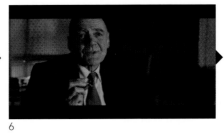

3

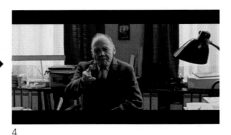

4

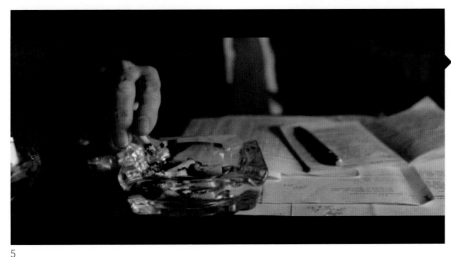

5

6

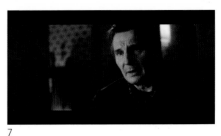

7

The Floating Corpse

What does it look like?
It's any shot that shoots from under the water up at a floating body. The person who found the body is often seen in the shot as well.

How's it done?
Use an underwater camera for this shot.

When should I use it?
Use this shot to reveal the face of the body floating in the water. The shot often has visual clues to how the person died.

SUNSET BOULEVARD (1950)

Synopsis: Running from debt collectors, screenwriter Joe (William Holden) stumbles upon the crumbling mansion of former silent-film star Norma Desmond (Gloria Swanson). As he begins working for Norma, writing a comeback screenplay, their professional relationship evolves into something more.

Featured Scene: The opening scene where the police find a body in the pool.

Sunset Boulevard (1950), directed by Billy Wilder

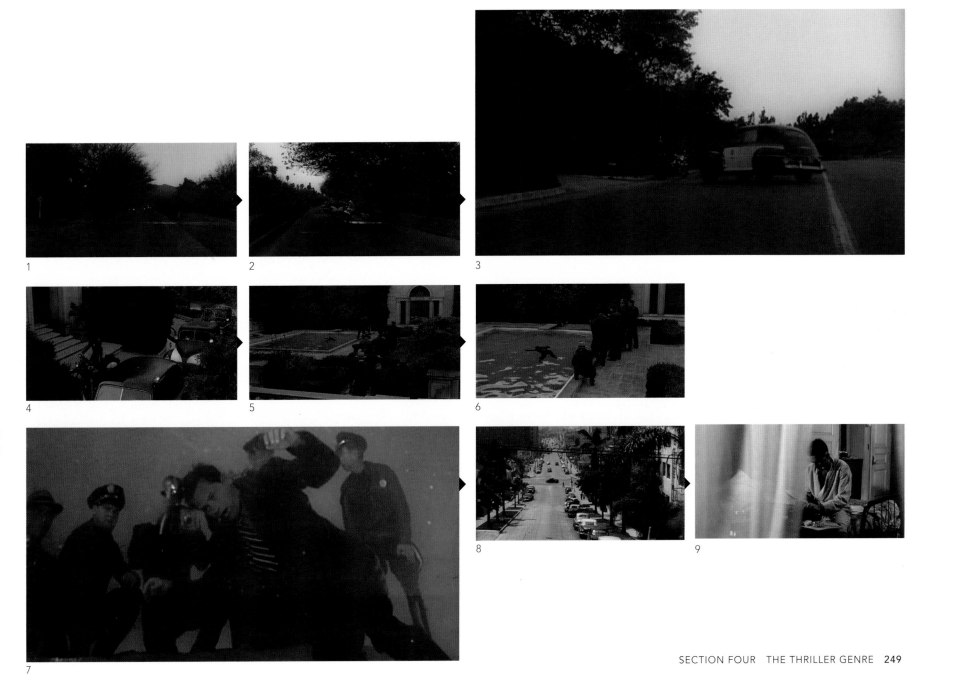

1

2

3

4

5

6

7

8

9